T0347710

MICROMOSAICS

MASTERPIECES FROM THE ROSALINDE AND ARTHUR GILBERT COLLECTION

Heike Zech

V&A PUBLISHING

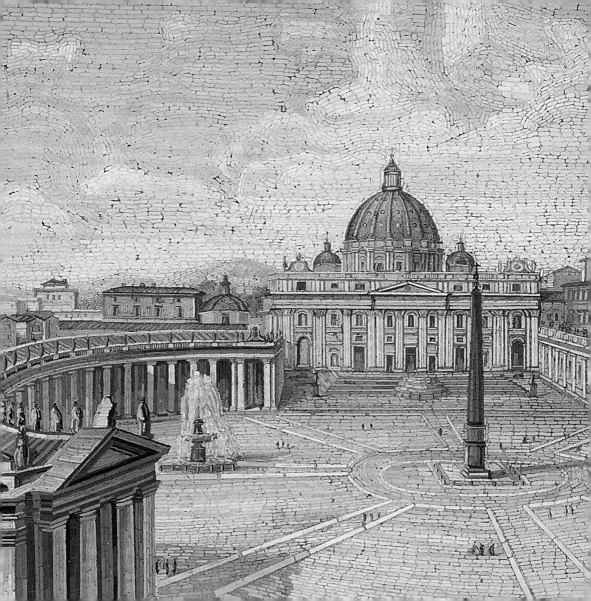

CONTENTS

no. 30 (detail)

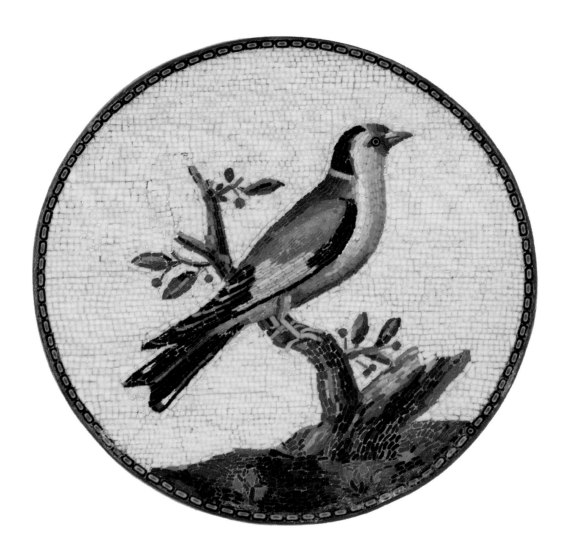

INTRODUCTION

Fig. 1
Goldfinch, attributed to Giacomo Raffaelli, micromosaic
Rome, 1775–1800, diameter 6.8 cm

Certain categories of art, however intriguing, tend to be treated with suspicion: do they qualify as art or craftsmanship, or are they better classified as *kitsch*? Micromosaics are one such category. After all, what are they? Until recently there was no established term in English to describe these small and very fine glass mosaics, most of which were created in Rome during the nineteenth century. The term 'micromosaic' was allegedly invented in the 1970s by Sir Arthur Gilbert (1913–2001), whose collection is featured here. These pieces range from a plaque depicting a bird (fig. 1) and measuring just 6.8 cm in diameter, dating from about 1800, to a much later fanciful tavern scene after a painting in a revival style by Francesco Vinea (1845–1902), relatively large at 63.5 cm wide (no. 50). Looking at these two objects together, as defining components of the masterpieces from the Rosalinde and Arthur Gilbert Collection at the Victoria and Albert Museum, reveals the unique qualities of the form, irrespective of changing tastes over the nineteenth century. This small volume unashamedly celebrates micromosaics and applauds the Gilberts'

foresight in assembling one of the most significant collections in the world. It is a personal selection, intended to offer that all-important second glance. It is a guide rather than a scholarly appraisal, written to complement the existing catalogues of the collection by Alvar González-Palacios, Steffi Röttgen, Anna Maria Massinelli and, more recently, Jeanette Hanisee Gabriel and Judy Rudoe. While the 50 object stories focus on sources, makers and markets, this introduction explores the art form through the choices made by artists, looking at size, material and technical perfection, style and originality: the choices that many feel signify art and spectacular craft.

Size: The Art of Reduction

'Our times are worse than we think', concluded Johann Wolfgang von Goethe (1749–1832), writing about the new fashionable miniature mosaics during his Italian trip of 1786–8. 'The art of mosaics, which once gave the Ancients their paved floors and the Christians the vaulted heaven of their churches, has now been degraded

to snuffboxes and bracelets.'[1] For him, the reduction in size was clearly a fall from grace. With this remark, Goethe dismisses micromosaics as a trivialization of the great heritage of mosaics. Ancient mosaics shared the gravitas of the buildings they adorned, and were contextualized by the architecture around them. The reduction in scale therefore signified a translation into a format historically perceived as less noble in the traditional hierarchy of art forms: decorative art. English traveller Charlotte Eaton (1788–1859), who lived in Rome in 1817–18, at least conceded that micromosaics were 'the most remarkable of the many fine arts practised at Rome'.[2] With this she cautiously positioned these pieces beyond the merely decorative.

And yet, precisely as a result of their portability, micromosaics arguably became a more independent art form than many of their classical predecessors. The portability of mosaics has ancient roots, and was sometimes the mark of a particularly fine work: in 1737, Cardinal Giuseppe Alessandro Furietti (1685–1764) discovered one of the finest ancient mosaics known today at the villa of Emperor Hadrian (76–136) in Tivoli. The mosaic is named after Pliny the Elder's (23–79) description in his *Natural History* of a highly naturalistic depiction of doves resting on a bowl by Sosos of Pergamon (second century BC). Henry T. Riley (1816–78) and John Bostock (1773–1846) translated the description of these *Doves of Pliny* during the height of the popularity of micromosaics: 'There is a dove also, greatly admired, in the act of drinking and throwing the shadow of its head on the water, while other birds are seen sunning and pluming themselves, on the margin of a drinking bowl.'[3] Unlike most ancient mosaics, the *Doves of Pliny* from Hadrian's Villa is set as a so-called emblem mosaic on its own slab of marble: the piece could be extracted from the floor without damage, and displayed in a different context, just as a painting can be moved around. Hence, the smaller size and finer quality elevated the *Doves of Pliny* mosaic to the category of fine art.

The excavation of the mosaic at Hadrian's Villa inspired mosaicists in eighteenth-century Rome to attempt to equal its lifelike quality, technical perfection and longevity.

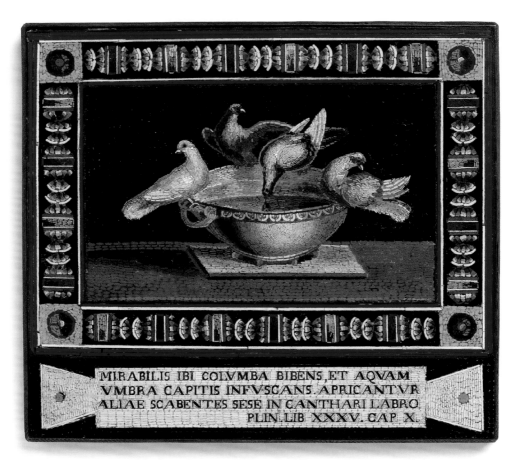

MIRABILIS IBI COLVMBA BIBENS, ET AQVAM
VMBRA CAPITIS INFVSCANS, APRICANTVR
ALIAE SCABENTES SESE IN CANTHARI LABRO.
PLIN.LIB XXXV. CAP. X.

7

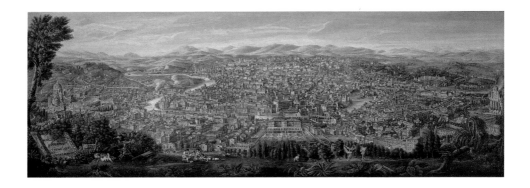

Indeed, the ambition to compete with the masterpieces of antiquity characterizes the work of European artists around 1800. Micromosaicists were no exception. They also found inspiration in contemporary painters, such as Jacob Philipp Hackert (1737–1807, no. 1) and sculptors, including Antonio Canova (1757–1822, no. 9). As well as ancient portable mosaics, painted and printed portrait miniatures (no. 43) and small-scale images of saints (no. 41) are likely to have contributed to the popularity of micromosaics.

Throughout the last decades of the eighteenth century, materials and techniques were developed that allowed the creation of remarkably small-scale mosaics. By the 1790s mosaicists could render any subject, including the *Doves of Pliny* (fig. 2; no. 13), to perfection. Tiny plaques were produced, many of them for incorporation into portable objects such as jewellery and snuffboxes. The same workshops also produced larger panels as wall pictures using the same fine tesserae, yet few micromosaics exceed a metre in length or height. Gioacchino Rinaldi's (active 1800–25) ruins of Paestum (no. 32) is one of the largest micromosaics in the Gilbert Collection, with a width of 167 cm and Antonio Testa's remarkably detailed view of Rome (fig. 3) is 132.2 cm wide.

Material and Technical Perfection:
Deception as Ambition
Larger micromosaics are especially convincing as imitations of paintings. The aim of creating 'eternal pictures' in glass rather than paint has informed mosaic making since ancient times. The viewer does not question the

Fig. 3 (opposite)
View of Rome, Antonio Testa, micromosaic, Rome, 1800–20, height 47.7 cm, width 132.2 cm

Fig. 4 (right)
St Peter's Square in Rome, micromosaic set in a snuffbox, Rome, *c*. 1850, diameter 5.7 cm, height 3 cm. The broken plaque showing tesserae in cross-section.

material until, on closer inspection, they are surprised by the presence of the tesserae (fig. 4). Pliny the Elder tells the story of the competition between ancient painters Zeuxis and Parrhasius (fifth century BC), which was resolved when Zeuxis attempted to move a curtain painted by his rival. The effect Parrhasius had created was a *trompe l'œil*. It is the same quality that Pliny praised in the *Doves of Pliny* mosaic, and which micromosaicists sought to emulate through perfecting their materials and technique. The Vatican Mosaic Workshop, established in the second half of the sixteenth century, had a tradition of copying paintings in mosaic even before the advent of micromosaics. From the seventeenth century onwards, in addition to decorating the dome of the new St Peter's Basilica, the workshop was commissioned to replace the large-scale altar paintings with mosaic copies. One of the reasons was possibly to protect the fragile paintings from the humid conditions within the vast basilica.

These 'paintings in glass' were set using traditional mosaic techniques and materials. Typically, ancient mosaics were made of stone, although some included glass and ceramic tesserae. The size of a tessera depends on the amount of detail required, and the final size of the mosaic. The shape of a glass tessera, even in eighteenth-century work produced at the Vatican workshop, was normally a cube, cut from a larger disc of glass – a *pizza*. Opaque glass, known in Italian as *smalto* (the word also used for 'enamel'), was introduced in mosaic making when mosaics first adorned the walls of Christian churches. But there were limits as to how small these glass cubes could be cut, so micromosaic makers developed the technique of drawing long, slender canes from heated malleable glass, from which even smaller pieces could be cut to create more nuanced, lifelike pictures. These bespoke tesserae were produced 'just in time', while the setting work was in progress.

Fig. 5
Princess Augusta of Bavaria (detail),
Teodoro Matteini, oil on canvas, *c.* 1806–10,
height 73.5 cm, width 58 cm

The development of the colour palette was as important as the development of the setting technique and Alessio Mattioli, responsible for the production of material for the Vatican workshop from the 1730s onwards, took a lead role in this. By the early 1800s makers could draw on an astonishing range of colours. As demand increased, mosaicists improved their efficiency by fusing two or more different colours of glass into one cane – a *malmischiato* (Italian for 'badly mixed'). These canes, with their clearly distinguishable colours (see the realistic petals of no. 15), facilitated increasingly fine, detailed micromosaics on the smallest of plaques. The process of translating a composition from its painted or engraved source with thousands of tiny tesserae is highly individual and creates unique results as can be seen in the versions of the *Doves of Pliny* shown in this volume (fig. 2 and no. 13). In the final stage of production, most micromosaics were polished and treated with beeswax, which was sometimes coloured, to conceal the spaces between

the tesserae. This ensured that the surface appeared closed and glossy.

The concentration, patience and steadiness of hand required to create micromosaics so fine that the craftsmanship remains almost invisible is astonishing. That this technique was, to some extent, developed within the institution of the Catholic Church might be significant since there are notable parallels with other crafts that have flourished within religious institutions. Among them are the so-called *Klosterarbeiten* ('works made in monasteries') – meticulous works of wire and paper made in Catholic central European monasteries as frames and mounts for holy relics and religious prints. In Victorian England, mosaic making was considered a 'very useful and healthful occupation'[4] and was therefore particularly suited to the reform of female convicts. Floor tiles produced by women convicts are known today as *Opus Criminale* in reference to the Latin term *Opus Musivum* for mosaic work more generally. Examples can still be seen at the Victoria and Albert Museum and in the crypt of St Paul's Cathedral, London.

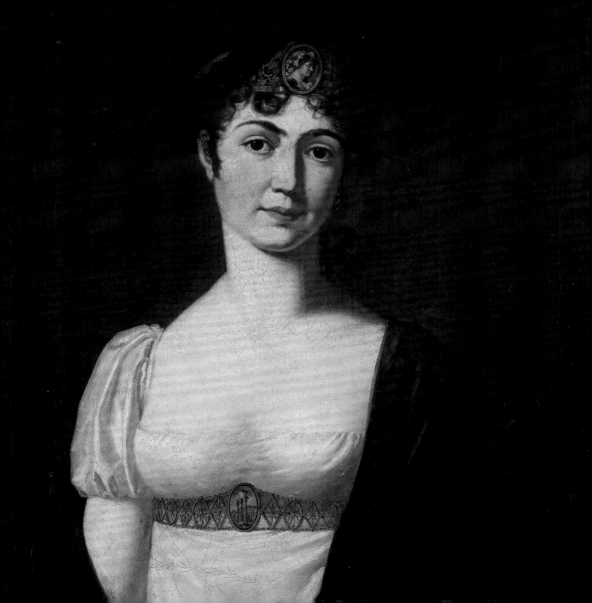

Fig. 6
Clock with hardstone and micromosaic decoration,
Giacomo Raffaelli, Rome, 1804, height 90.2 cm,
width 51.1 cm, depth 20.7 cm

Style: Between Avant-garde and Mainstream

When micromosaics first emerged, they were sought after by a fashion-defining cultural elite who considered the new technique and designs stylish. Even if Goethe disapproved of miniature mosaics inspired by antiquity, they were anything but the nineteenth-century equivalent of a souvenir T-shirt. Even around 1800 there were two distinct markets: royalty and the rest. Only the leading houses of Europe commissioned bespoke micromosaics; the remaining production was ready-made, mainly for visitors to Italy. Ancient art was the first point of reference for micromosaics: early examples emulated antique mosaics or depicted ancient marble sculpture (no. 8) and other artefacts (nos 3; 5). Because of their size and imagery micromosaics were an ideal vehicle for the tastes of the elevated circles of European society. The portrait of a young lady in a white dress exemplifies this (fig. 5). The sitter, Princess Augusta of Bavaria (1788–1851), was the wife of Napoleon Bonaparte's stepson and Viceroy of Italy, Eugène de Beauharnais (1781–1824, viceroy 1805–14). Her jewellery

alludes to Italy: the artist has painted, in minute detail, the oval jewel-like pictures on her belt and tiara, which are probably micromosaics. They are depictions of the Temple of Castor and Pollux on the Roman Forum and the head of the god Bacchus. Both declare her as regal ambassador of her adopted country, and are prime examples of the style championed by Napoleon's inner circle. Napoleon Bonaparte (1769–1821) was fundamental in carrying the technique beyond the Vatican, establishing workshops in Milan and Paris (no. 9). The symbols and aesthetics of ancient Rome formed the nucleus of the visual identity of his reign, the so-called Empire style. Micromosaics as reinterpretations of an essentially Roman art form were the perfect vehicle for the expression of this taste. Napoleon was given two exquisitely made and superbly elegant gifts with micromosaic decoration by Pope Pius VII (1742–1823, pope from 1800) on the occasion of his coronation in 1804 (fig. 6; no. 7). The clock shown here was made by one of the foremost micromosaicists around 1800, Giacomo Raffaelli (1753–1836), who

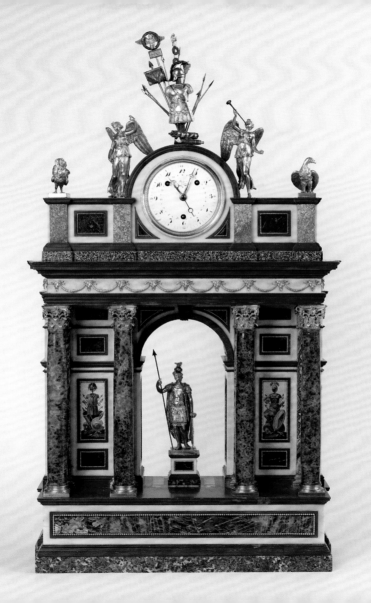

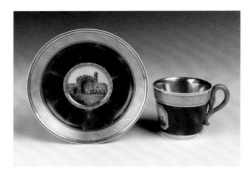

Fig. 7
Porcelain cup and saucer painted with imitation micromosaic, Berlin, made at the Royal Porcelain Manufactory, c. 1805; cup diameter 8.7 cm, height 7.2 cm, saucer diameter 15.2 cm, height 2.9 cm

also established a workshop for Napoleon in Milan. The royal taste for micromosaics was also evident in Berlin: around the time of Napoleon's coronation the Royal Porcelain Manufactory in that city, decorated cups and saucers with hand-painted micromosaics, mostly in the style of Raffaelli's studio (fig. 7). They are unique and witty reproductions of this technique.

After Napoleon's fall in 1815, other European rulers and noblemen became key patrons of mosaicists working beyond the Vatican. In particular, the Russian tsars imported masters, expertise and works from Italy. Tsar Nicholas I (1796–1855, ruled from 1825) commissioned several tables from Cavaliere Michelangelo Barberi (1787–1867), who excelled in devising complex tabletop designs. Barberi's creations for the Russian imperial family (nos 30; 33) were both a

record of the family's experience of Italy and his silent statement on the cultural unity of Italy at the time of the Risorgimento ('resurgence, revival') movement for a politically united Italy. Barberi published this and other designs in 1856 in an album entitled *Mosaics From the Studio,* which he dedicated to student mosaicists. His manifesto expresses his reservations about the increasing commercialization of his trade:

> This art form at first appears so easy, if undertaken commercially, but it proves to be difficult, indeed extremely so, if one aims to practise it as artist and philosopher. I want to urge you, to not limit yourself to the purely mechanical aspects of mosaicmaking, but to also learn about drawing, the brush and the humanities. If you do so, it will be a great service indeed to yourself and to Rome with its already significant trade in mosaics.[5]

Barberi's plea is a response to a development observed by Charlotte Eaton: 'There are hundreds of artists, or artisans, who carry on the manufactory of mosaics on a small

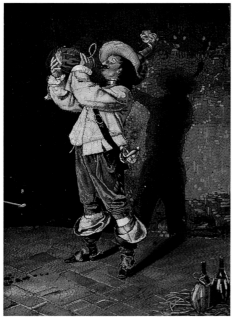

where precious *pietre dure* ('hard stones')
mosaics were increasingly based on recently
painted genre scenes, including versions of
the drinking cavalier. These works reflect a
changing audience and a shift in fashion:
during the second half of the nineteenth
century, taste moved away from classical gods
and heroes to themes that emulated more
recent centuries, such as figures of soldiers
in historic costume and seventeenth- and
eighteenth-century interiors (nos 24–5). These
popular scenes were highly idealized and often
romantic visions of the past. To some they are
the essence of bad taste, or *kitsch*. Indeed the
term *kitsch* was coined by German art dealers
of the period for works of this type.

Originality: Idea and Execution

Micromosaics depict a fairly small canon
of continuously repeated compositions:
drinking cavaliers play a minor role in the
overall production. Many of the bestselling
subjects on the more typical souvenirs
represented iconic artefacts and places.
With this in mind, one might wonder
where the line is drawn between an artful

scale. Snuff-boxes, rings, necklaces, brooches,
earrings, &c. are made in immense quantity.'⁶
Barberi's appeal remained to some extent
unheard during the second half of the
nineteenth century as mosaicists broadened
their repertoire to include more recent sources.
The picture of a drinking cavalier (fig. 8)
would probably have shocked, Barberi, yet the
same phenomenon also occurred in Florence,

recreation that is original in itself, and the 'purely mechanical' reproduction described by Barberi. This can be linked to another, more fundamental question that had been part of the discourse about art from the Renaissance onwards: what is the relationship between the invention of a design and its physical execution? And what, therefore, is the function of a copy? Galleries of copies remained an important teaching tool before the advent of photography, and copying was, at times, the only type of instruction offered by eighteenth-century art academies. To have any instructive value, a 'good copy' had to repeat the original as nearly as possible, and yet art historian and archaeologist Johann Joachim Winckelmann (1717–68) argued that even the best 'small copy is only a shadow, not the truth'.[7] The debate was particularly lively around to one of the most iconic works of all time, Leonardo da Vinci's (1452–1519) *Last Supper* in Milan, painted in the late 1490s. By the 1800s Leonardo's original masterpiece was barely visible because it had been painted onto a dry wall rather than in fresh plaster, as in the fresco technique. The

paint had started to peel off the wall in the 1500s. The debate about how to preserve the painting led to the commissioning of a mosaic copy by none other than micromosaic pioneer Raffaelli at his Milan workshop. The cartoon used for Raffaelli's mosaic is a copy and scholarly reconstruction of Leonardo's work by painter and art writer Giuseppe Bossi (1777–1815). The mosaic reconstruction, now at the Minoritenkirche, Vienna, was an attempt to create an everlasting version of the painting. Thankfully, the original *Last Supper* can still be seen in Milan, but the commission brought wider attention to the potential of mosaics as a means to create 'good' and eternal copies, and also promoted Raffaelli's workshop and its production.

Leading sculptor Antonio Canova, who selected Pope Pius VII's gifts for Napoleon (no. 7), appears to have welcomed the new medium for slightly different reasons. A version of his figure of Hebe was at Empress Josephine's (1763–1814) Château de Malmaison. For the same house, Francesco Belloni (1772–1865) made a micromosaic tabletop with a two-dimensional

interpretation of Canova's *Hebe* (no. 9). The aim of this creative copy juxtaposed with the original must have been to delight and startle rather than to instruct.

Micromosaicists continued to make copies throughout the nineteenth century, but some also worked to their own designs, particularly Giacomo Raffaelli (fig. 1; nos 8; 14), Michelangelo Barberi (nos 30; 33) and Georgi Ferdinand Wekler (1800–61; nos 39; 40). As already mentioned, Barberi specialized in tabletops, a comparatively large canvas for his ideas about art and the cultural unity of his country.

A Future for Micromosaics?

As the century progressed, production continued to embrace the extremes of outright copy versus original commission, adapting to the changing preferences of a century in which taste was dictated less and less, no longer the almost exclusive preserve of the courts of Europe. Micromosaics were not immune to what Norbert Elias (1897–1990) described as the *Formunsicherheit* of the nineteenth century, an 'uncertainty

regarding taste', [8] which to him resulted from the diminished influence of court style and was at the heart of *kitsch*. Hence, the adverse reaction to some micromosaics may have more to do with a general unease about contemporaneous works of art than with the art form itself. Around 1900 photography became the new benchmark for lifelike images (no. 47), a challenge to which micromosaicists responded by including so-called *murrine* pieces. The cross-section of these prefabricated canes showed a whole segment of a mosaic, such as a face, adding more detail to the finished article without slowing down production. Nonetheless, from around 1900 fewer and fewer micromosaics were produced. It is thanks to Arthur and Rosalinde Gilbert that today historic micromosaics are back in fashion, and are collected and studied more widely than ever before. The Gilberts, both born in London in 1913, owned a fashion company in their youth and, after moving to Los Angeles in 1949, went on to form one of the most important decorative arts collections of their time (on loan to the V&A since 2008). In collecting

Fig. 9
Ice Camp, Kirsten Haydon, brooch, enamel, photo transfer, reflector beads, copper, silver and steel, Australia 2014, diameter 8 cm, depth 1 cm

'not for themselves, but for everyone', they selected unusual categories: micromosaics, gold boxes, painted enamel miniatures, sacred and secular objects in gold and silver. In each of these fields, their collection excels, and in addition they commissioned and inspired groundbreaking research. The presentation of the Gilbert Collection at the V&A shows that decorative art is never merely decorative, but is also replete with ingenuity, style and historical context.

Through inspiring the makers of today, historic masterpieces can be a bridge from the past to the future. Dolce & Gabbana made *Marvellous Mosaics* the theme of its Autumn/Winter 2014 collection, which included handbags with micromosaic applications as one of many references to Italy's mosaic history. Today, there are just a handful of micromosaicists: the Vatican workshop continues the tradition of papal micromosaics, reflecting the best of the technique. Other mosaicists work with the traditional *smalti* to produce bespoke work and small editions of luxury accessories, including watches, sunglasses and jewellery,

even introducing imagery based on the contemporary vocabulary of punk, rock and glamour. Melbourne-based New Zealand artist Kirsten Haydon (born 1973) has taken to heart Barberi's plea to look beyond the mechanical, returning to the origin of the word *smalto* – enamel. Her micromosaics (fig. 9) reference the size and shape of the Italian Grand Tour plaques devised by Raffaelli's generation (fig. 1; nos 34; 36) but take us to an entirely different world – Antarctica. Using photographs taken during a fellowship, she prints enamels onto which she fuses dots of colourless glass. The effect is a delicate surface that evokes both the grid of early micromosaic backgrounds and the miraculous forms of snow crystals. Her work allows the viewer to cradle a mirage-like vision of Antarctica, a tangible reminder of the fragility of its ecosystem. Micromosaics are by no means an art form locked in the past. Both their materiality and the themes they address continue to evolve as expressions of the world.

NOTES

1 Goethe trans. 1970, p. 94
2 Eaton 1852, vol. 2, p.309; Gabriel 2000, p. 30
3 Bostock and Riley 1857, p. 376
4 Zech and Jesnick 2015; Zech 2015, pp. 34–42

5 Barberi 1856, p. 2
6 Eaton 1852, vol. 2, p. 311
7 Winckelmann 1763, p. 17
8 Elias ed. 2004, p. 6

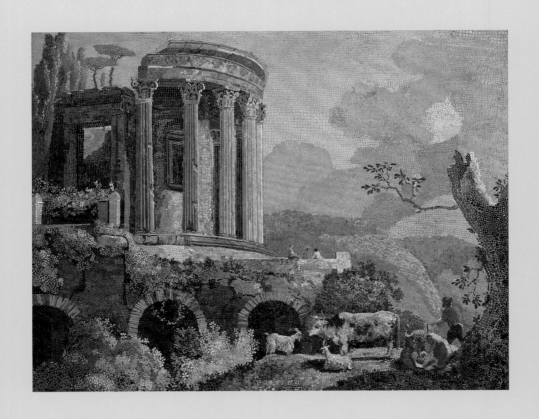

A ROMAN INVENTION

The earliest micromosaics were made in Rome, in the orbit of the
Vatican Mosaic Workshop, during the second half of the eighteenth
century. They offer a dazzling variety of imagery – from the very
beginning, makers were inspired by Italian art and nature. They
looked to both ancient and contemporary sources for themes that
might appeal to an international clientele. The mosaics shown in
this section showcase the virtuosity of the early micromosaicists.
They also give a glimpse into the world in which they were created:
while early fan guards and snuffboxes were typical eighteenth-
century luxury items, a faster production of souvenir-type jewellery
also became popular. Rome, with its magnificent heritage and as
the meeting point for culture-hungry northern Europeans, was the
natural place of origin for this new technique.

no. 1

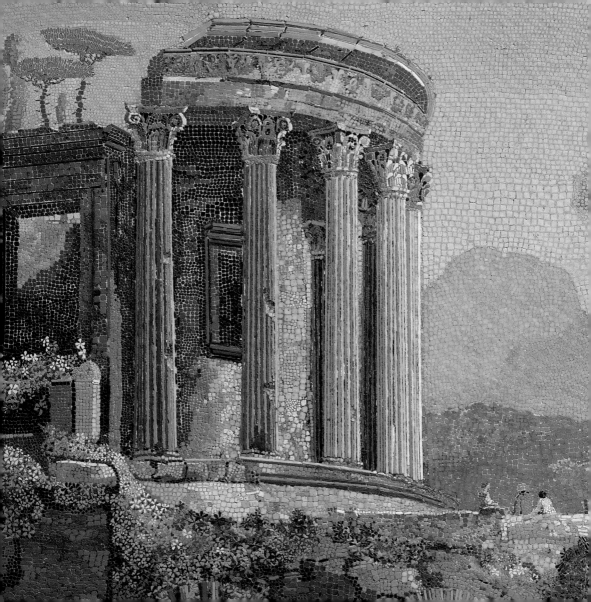

Temple of the Sybil at Tivoli after Jacob Philipp Hackert

Attributed to Giacomo Raffaelli (1753–1836), Rome, *c.* 1777

This piece, after a painting by Hackert (1737–1807), a German painter living in Italy from 1768, shows how a micromosaic pioneer created a copy of a painting, despite access to a still fairly limited colour palette. Where a painter might have gently faded the colour of the sky, Raffaelli created a sense of infinity through the graduation in size of small pieces of glass. The mosaicist also had to be inventive in his depiction of the landscapes, animals and temple, in effect creating a picture that anticipates the work of Pointillist painters a century later. The painting captures one of the most important sights of the eighteenth-century Grand Tour. The dedication of the famous ruins remains unclear: today, the remnants of the circular structure are referred to as the Temple of Vesta. Incidentally, the cows are an addition to Hackert's version, now at the Gemäldegalerie Alte Meister, Dresden.

Height 43.5 cm, width 53.4 cm; see also p. 20

Partly legible inscription at base: 'F. Rael[...]l[..]Roma, 1777 or VII'

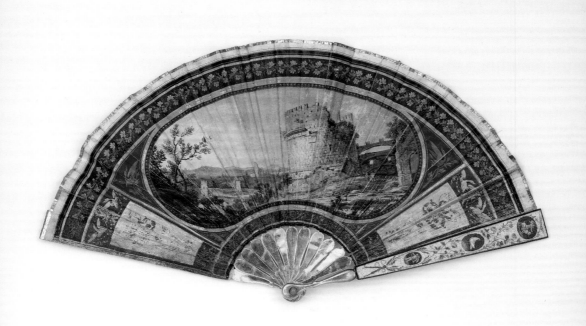

2

Putti, dove and flowers

Rome, 1790–1820
set in a fan guard

In the late 1700s a tour to Italy – part of the
Grand Tour – was still a defining moment
in the life of young, wealthy, but primarily
male, northern Europeans. It was a moment
intended to refine their taste and complete
their education. Like most tourists, these
travellers went in search of exclusive
souvenirs of their life-changing experience.
Exquisitely made pictures of the sights of
Rome were sought after, including painted
fan leaves such as shown here. This example
combines a delicately painted leaf with sturdy
and unusually heavy fan guards decorated in
the new micromosaic technique. The mosaic
brings together various symbols of love:
roses frame three reserves with Amor and a
dove. The mosaics are still in good condition,
which implies that the fan was probably a
treasured object.

Fan: height 18 cm, width 32.5 cm
Micromosaic guard: height 15.5 cm, width 2 cm
(maximum)

3
Etruscan amphora

Rome, *c*. 1800
set in a ring, possibly in Rome

The invention of micromosaics served a
market hungry for ever-more sophisticated
and novel ways to take Rome home, mostly
to northern Europe. What could be more
portable than this small micromosaic plaque?
This depiction of an amphora evokes the
civilization preceding the Romans in ancient
Italy. The success of miniature mosaics from
the late 1700s onwards may have resulted
from the merging of shapes and forms that
were immediately recognizable to tourists
with a maker's technique that was equally
associated with antiquity. The simplified and
updated rendition of antiquity depicted here
required artistic talent, suitable materials and
extraordinary craftsmanship, as evident in the
economic yet effective treatment of light and
shadow on the amphora's body, which has
been created using eight different colours.

Height 3.2 cm, width 1.9 cm (shown right at actual size)

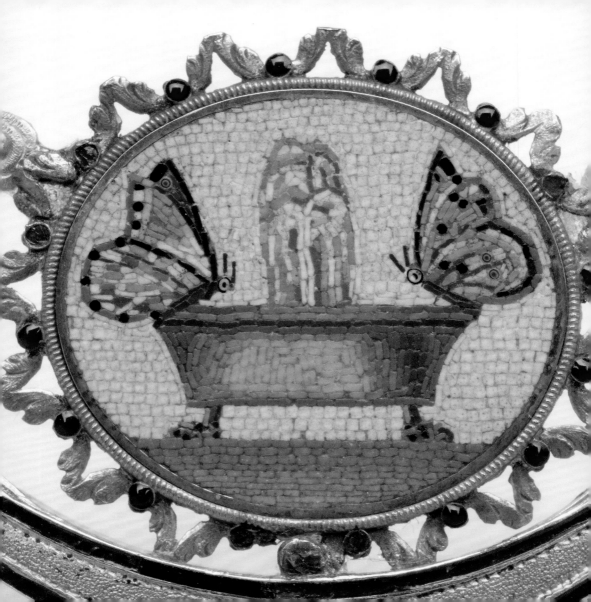

4
Butterflies and Etruscan lamps

Rome, *c.* 1810
set in a comb

Micromosaics were often produced as
small plaques set in metal trays that could
then be used to decorate an object. Here
three plaques are incorporated into a
highly fashionable comb, produced using
techniques that are typical of the early
nineteenth century. The artist used just a
few, mostly earthy, colours in contrast with
a striking orange. The central plaque shows
butterflies resting on the rim of a fountain;
the other two depict Etruscan oil lamps. This
imagery refers back to ancient Rome, when
butterflies were symbols of the transience
of life and also of death. Likewise oil lamps,
when extinguished, could be a symbol of
death, though here they are shown alight.
Together with the central bubbling fountain,
the panels might have been intended as a
symbolic celebration of life. Given the large
number of surviving butterfly micromosaics,
they were clearly a popular theme.

Comb: height 9.7 cm, width 8.5 cm, depth 1.9 cm

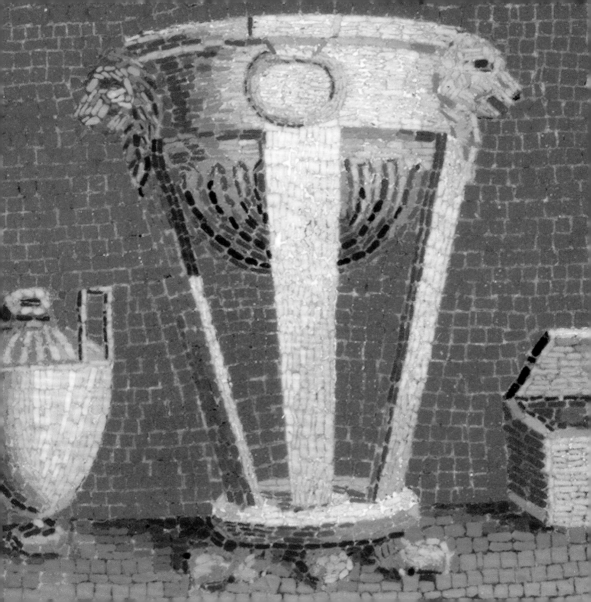

5
Amphora, tripod and casket

Rome, *c.* 1800
set in a snuffbox

Thanks to artists such as Giovanni Battista
Piranesi (1720–78), prints of ancient sites were
increasingly available throughout Europe,
leading to a change in the perception of
classical antiquity. Original artefacts were
bought by northern European princes and
scholars, while others found their way into
the new public museums. This new-found
interest sparked a revival of the style of
ancient Rome, a reinterpretation now known
as neoclassicism. This plaque shows how the
newly emerging taste could be compressed
into simple forms that served as shorthand
for the style. It is thought that the three-
legged tripod at the centre could allude to the
tradition of presenting tripods to victorious
warriors and athletes. Several such bronze
tripods had recently been found at Olympia.
The maker distinguished two zones: the
background and floor formed of square-
shaped tesserae, and the objects formed of
smaller rectangular ones.

Snuffbox: diameter 7.8 cm, height 1.2 cm

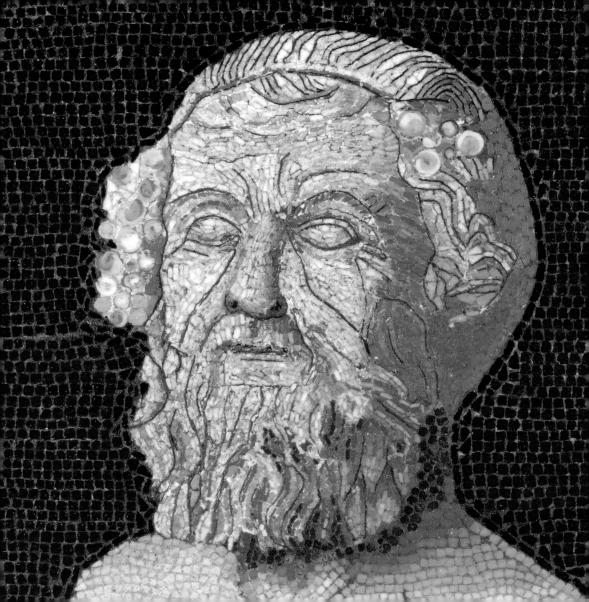

6

Bust of Socrates

Rome, *c*. 1800
set in a snuffbox

No actual portrait of the philosopher Socrates
(*c*. 470–399 BC) is known. Since antiquity
the face depicted here, with its balding head,
beard and broad nose, has come to represent
his character as immortalized in writing
by his student Plato (*c*. 427–*c*. 347 BC). The
mosaic is after a Roman marble copy of a
Greek original at the Capitoline Museums,
Rome. This, too, has slots on the sides, maybe
for wooden inserts from which garlands
could be hung. This small plaque exhibits
an important advance in the depiction
of marble sculpture, thus broadening the
canon of subjects that could be rendered in
micromosaic. Despite a limited colour palette,
the artist has expressed a white marble
sculpture through the skilful use of *andamento*
(the flow of the line in which a mosaic is
laid) and metal strips. Circular tesserae,
some of them two-coloured, represent the
philosopher's wild, unkempt hair.

Snuffbox: diameter 10.4 cm, height 2.4 cm

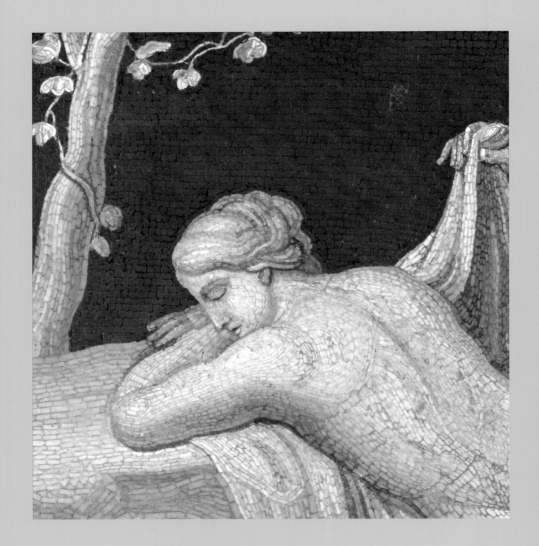

INSPIRED
BY ANTIQUITY

During the 1700s the ancient mosaic floors that were scattered throughout Italy became increasingly well known, but they were not the only genre of ancient Roman art that was revered and studied. Micromosaicists could also draw inspiration from monumental marble figures, vases, wall paintings and architecture. As scholars strived to understand and classify the discoveries emerging from archaeological sites,a generation of international collectors sought to secure the most prestigious pieces for their collections, while artists produced prints and completed fragmented masterpieces, either on paper or as three-dimensional works. Micromosaicists served them all by absorbing the imagery of ancient works into their own creations. In contrast to the mosaics in the previous section, the micromosaics on the following pages are no experimental explorations but are some of the very best in this art form.

no. 8 (detail)

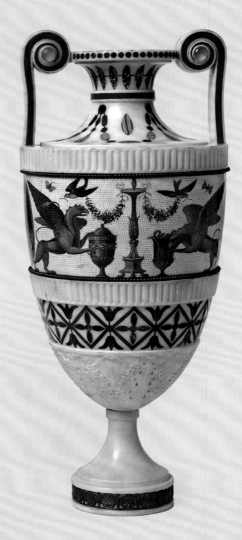

7
Griffins and tripods

Nicola de Vecchis (died *c.* 1834), Rome, *c.* 1795–1800
set in a pair of amphorae

These extraordinary marble vases showcase micromosaics as an art form that had matured in terms of material, technique and design. Carefully selected by leading artist Antonio Canova, they were among the gifts of Pope Pius VII to Napoleon on the event of his coronation as emperor in December 1804. Their style reflects Napoleon's taste in the decade leading up to his coronation. The imposing griffins, each unique, were inspired by, but not copied from, ancient art. Associated in antiquity with divine power, griffins are a fitting image for a gift from a pope to an emperor. The micromosaic panels curve to follow the shape of the vases, the tesserae colours chosen to match those of the semi-precious stones inlaid below. Inlays such as these were produced in Rome and Florence, but also in India, for example for the Taj Mahal, from the 1500s onwards.

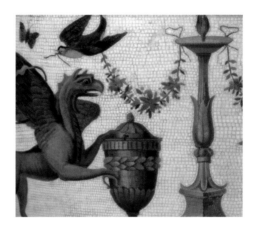

Amphorae: height 65.3 cm, diameter 22 cm (maximum)

8

Sleeping nymph and satyr

Giacomo Raffaelli (1753–1836), Rome, *c.* 1800–30

By the early 1800s, Giacomo Raffaelli had refined the materials and techniques used to make micromosaics to an extraordinary degree. The improvization necessary in his early work (fig. 1; no. 1) to compensate for a limited colour palette was no longer needed. Here, his restrained use of colour was a purely artistic decision, an interpretation of *en grisaille* (the imitation of stone figures and reliefs in tones of grey and white), a style used in ancient wall decoration. The subject too, of a nymph surprised by a satyr with goat feet, has an ancient precursor, though this interpretation is closer in style to the work of sculptors active during Raffaelli's lifetime, most important among them Antonio Canova.

Height 25.2 cm, width 22.5 cm; see also p. 34

Labelled at back: 'Jacques Raffaelli/Etude Mosaiques/ de travaux en tout genre. de marbres/a Rome/Rue du Babuinon. 92/près du Theatre dMibert' [*sic*]

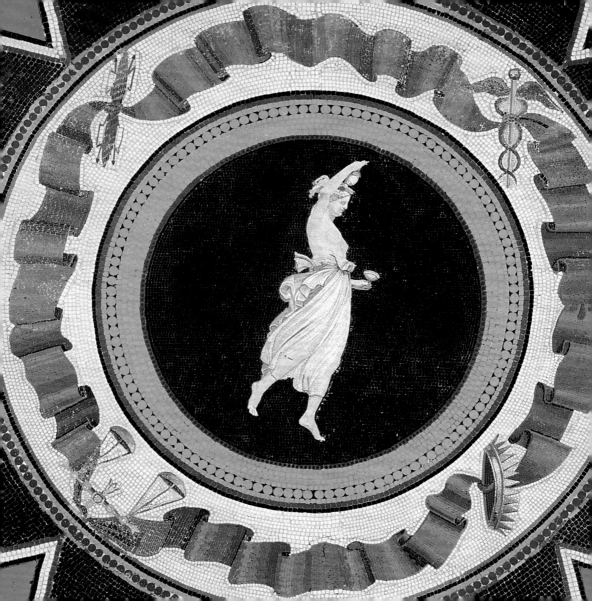

Hebe after Antonio Canova

Francesco Belloni (1772–1865), Paris, *c.* 1810
set in a table

Larger micromosaics, such as this tabletop, depicting Hebe, the goddess of youth and cupbearer for the Greek gods, were created as statement pieces to impress. In this instance, the ancient imagery takes on a neoclassical Italian guise. Hebe was rarely depicted in ancient art, but became a popular subject during the neoclassical period. In this micromosaic she follows a life-size sculpted marble by Antonio Canova dating from 1796, one version of which was displayed at Empress Josephine's Château de Malmaison where this table was also recorded (p. 17). Famed for its sensuality, Canova's *Hebe* was copied and reproduced in various media but this may well be the only version in glass mosaic. Probably using glass produced in France, the mosaic was put together by the micromosaic workshop set up in Paris by the Roman Francesco Belloni on instruction from Napoleon. The many repairs and harsh colour contrasts are indicative of an early production.

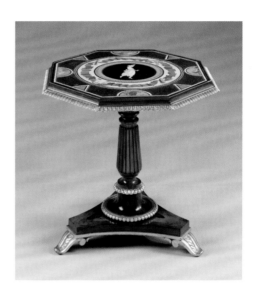

Table: diameter 72.5 cm, height 73.5 cm

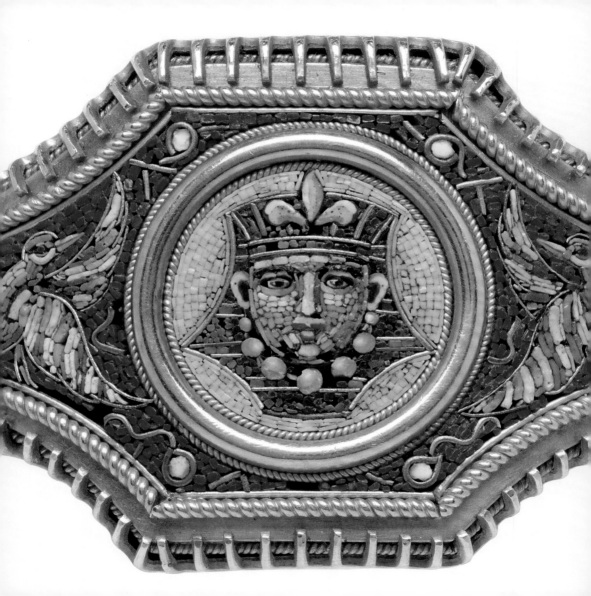

Egyptian heads

Rome, *c.* 1870
set in a bracelet

Around 1800, 'Egyptomania', a craze for ancient Egyptian art and themes, swept through Europe. The unpolished plaques set in the sides of this gold bracelet are part of a later wave of Egyptian revival and are inspired by representations of Egyptian pharaohs. Each plaque is a variation on the same theme, with the head at the centre, flanked by further quintessentially Egyptian motifs, such as birds, hieroglyphs, sphinxes and depictions of Anubis, the jackal-headed god. While glass mosaics were unknown in ancient Egypt, glass beads and enamel decoration in bold, striking colours are found in Egyptian jewellery. This bracelet pays tribute to its ancient predecessors through the strong colours of its gilded and translucent glass, the unpolished and uneven surface sparkling to resemble a beaded necklace. Metal strips have been used as they were in very early micromosaics (no. 6), to structure the mosaic and outline the individual motifs.

Bracelet: height 3.2 cm, width 7 cm

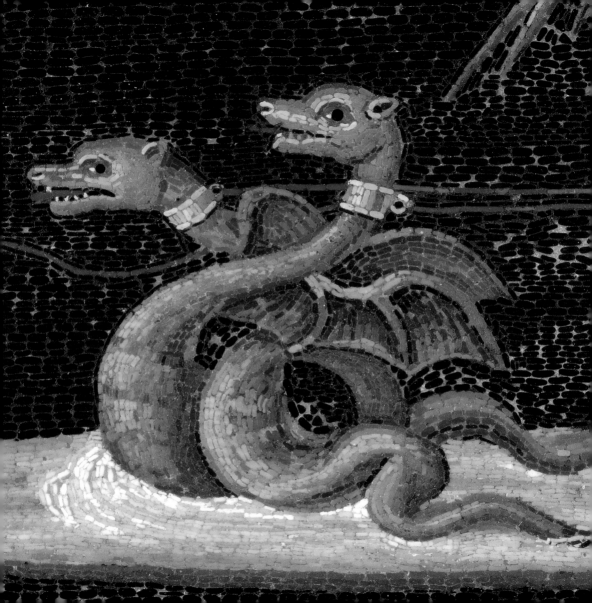

II

Cupid driving a shell chariot

Antonio Aguatti (died 1846), Rome, *c.* 1810
set in a snuffbox marked Pierre-André Montauban (active *c.* 1804–20), Paris, 1809–19

The subject of this mosaic would have been immediately recognizable to an early nineteenth-century audience. This particular depiction of Cupid (also known as Amor) riding in a chariot is an iconic classical motif. This example is a careful adaption from prints after the Renaissance fresco decoration at Villa Lante, on the Janiculum Hill, Rome. Executed by the workshop of the great Raphael (1483–1520) under the supervision of his student Giulio Romano (1499–1546), the frescos depict putti in various types of chariot drawn by animals both real and imaginary, each representing a different kind of love. Published in 1805, the prints inspired a popular series of gouaches by artist Michelangelo Maestri (1741–1812). The plaque is signed by Maestri's contemporary, micromosaicist Antonio Aguatti, who worked for the Vatican workshop and independently. Here he has matched the gouaches including the fabulous colour palette of the snakes' shiny scales.

Snuffbox: width 8.8 cm, depth 5.9 cm, height 2.3 cm

Signed 'Aguatti' at lower right

C. C. Ciul. Romano F. A. 1804

Head of Bacchus

Clemente Ciuli (active first half 19th century), Rome, 1804
set in a snuffbox marked Adrien-Jean Maximilien Vachette (1753–1839), Paris, 1809–19

One of the finest micromosaics in existence, this piece was made by Clemente Ciuli who resided at Piazza di Spagna, the main area for micromosaic workshops in Rome. In spite of the diminutive size of the roundel, the mosaic is brilliantly evocative of a sculpture or relief. Ciuli does not need the metal strips deployed by the maker of the Socrates bust (no. 6) to conjure an utterly convincing image of a three-dimensional work. Giuseppe Antonio Guattani (1748–1830) remarked on this quality when describing a similar mosaic by Ciuli in his *Encyclopaedic Records of Antiquities and Art in Rome* (1806–19): 'The minute scale, the uniformity and the invisible joining of pieces, suggests a drawing ... rather than a mosaic ... the imitation made by Ciuli appears to be also of marble; nor can one understand how these marvellous tiny tesserae create the impression of the fine lines of the brush of a miniaturist.'[1]

1 Guattani 1806–19, quoted after Gabriel 2000, p. 36

Snuffbox: diameter 8.3 cm, height 1.3 cm

Signed 'C. Ciuli Romano F.[ecit] A.[nno] 1804' at lower left

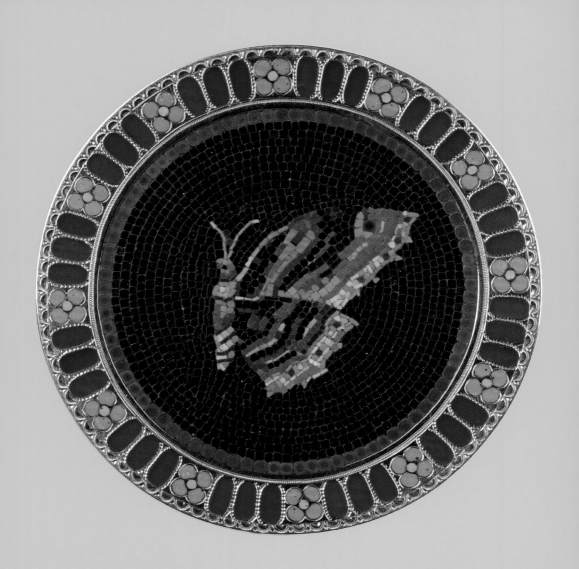

NATURE IN MINIATURE

Some early micromosaic masters, such as the maker of this fantasy butterfly, used nature as an inspirational springboard but made no attempt at exact replication. So while this butterfly celebrates the increasingly colourful world of micromosaics, it eludes identification as a specific species. For other mosaicisists, the imitation of nature to a degree that deceives the viewer became a key ambition. The most famous mosaic of this type is the so-called *Doves of Pliny*, made in the second century BC by Sosos of Pergamon as a portable floor panel, now housed at the Capitoline Museums, Rome. Repeating this work in micromosaic remained the ultimate challenge for micromosaicists throughout the nineteenth century, as the renditions on the cover, page 7 and overleaf show. The ancient mosaic inspired micromosaicists not only to recreate the famous composition but also to attempt new, increasingly realistic, even naturalistic, depictions of animals and plants.

no. 14 (base)

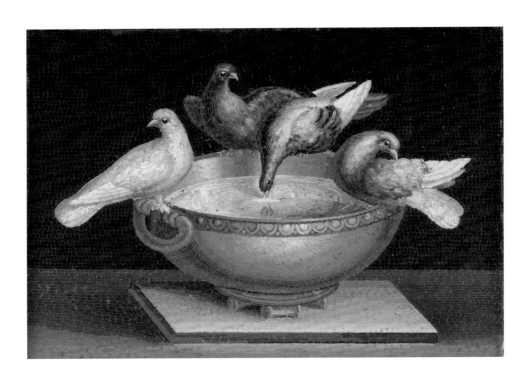

13
Doves of Pliny

Rome, *c.* 1830

In contrast to the Sosos of Pergamon *Doves of Pliny* at the Capitoline Museums, which is nearly a metre in height (see p. 6), the small plaque depicted left and on the cover of this book is just over 4 cm high. So tiny are its components that even at magnification the image does not dissolve into an abstract pattern of tesserae. Each rendition of the *Doves of Pliny* reveals its maker through the setting, the shapes of the tesserae and choice of colours, but the realism of this version is almost unsurpassed – it is the only version in the Gilbert Collection that shows the dove's reflection in the water. Raffaelli's earlier version of the *Doves of Pliny* (shown right) simplifies the original to suit the format and technical possibilities of his era. Dating a version of the *Doves* simply by looking at the perfection of the illusion is nonetheless impossible. Different qualities appear to have been produced even within the same workshop.

Above: The Capitoline Doves, Giacomo Raffaelli (1753–1836), Rome, 1801, signed and dated at the back

Diameter 7 cm (LG.194–2008)

Height 4.4 cm, width 5.7 cm

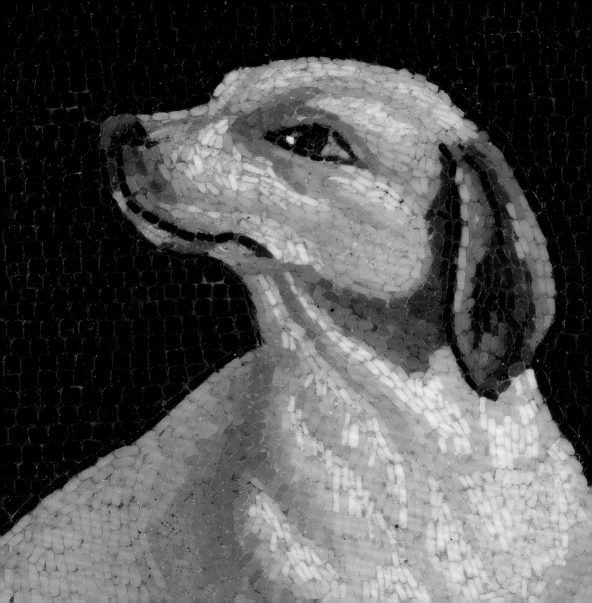

Dog and butterfly

Attributed to Giacomo Raffaelli (1753–1836), Rome, *c*. 1780
set in a bonbonnière by Johann Christian Neuber (1736–1808), Dresden, *c*. 1780

Roman micromosaics soon caught the eye of European makers of luxury objects, as this exquisite box by Johann Christian Neuber of Dresden demonstrates. Here, Neuber has incorporated two Roman micromosaic plaques (see also p. 48) into a box that is also set with hardstone mosaic, known as *pietre dure*, of lapis lazuli and turquoise. It is thought that Neuber might even have attempted to create micromosaic-like work himself. The plaques depict nature without naturalism as the ultimate goal. This is particularly true of the vibrantly coloured butterfly set in the base of the box and made with much larger tesserae than the dog. The mosaics are close enough in style and technique to those made by Raffaelli to be attributed to his workshop; Raffaelli also produced several versions of the *Doves of Pliny* (p. 51).

Bonbonnière: diameter 7.7 cm, height 3.3 cm;
see also p. 48

Floral bouquet

Rome, *c.* 1810
set in a snuffbox marked Carl Helfried Barbé (born 1777), St Petersburg, *c.* 1815

These stunning micromosaic plaques (the one on the lid protected by glass) are set in a finely made gold box produced in St Petersburg. Flowers are the overall theme of the decoration: they are chased in gold on the frame of the box, with different-coloured golds used to create contrast. The opulent mosaic on the main plaque is a painstaking attempt at a botanically accurate study of flowers, their light palette of pastel tones harmonizing with a pale blue background. Some of the petals have been created using *malmischiati* tesserae, which are produced through the fusion of two or more glass canes in different colours. The tiny petals on the lower left of the main plaque stand out for their combination of clearly contrasting colours: orange and purple, and two shades of dusty pink and green. The gold base of the lid is chased with the coat of arms of the Russian princes of Dondoukoff-Korsakov.

Snuffbox: width 8 cm, depth 6.3 cm, height 4.5 cm

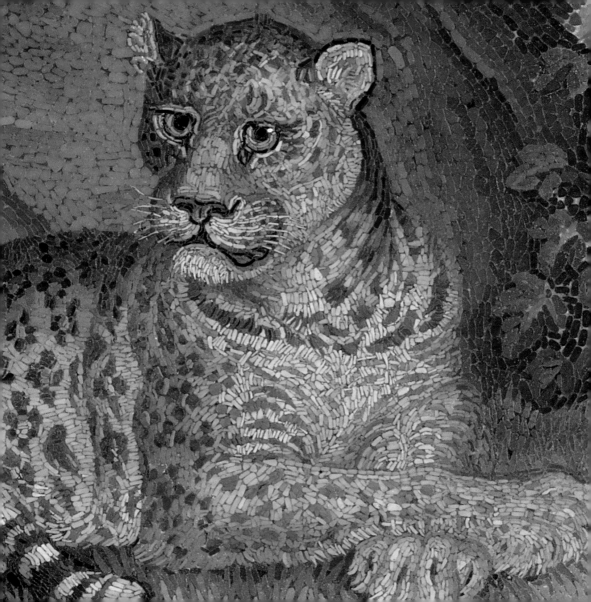

16

Leopard

Antonio Aguatti (died 1846), Rome, 1800–40

Early rendering of animal fur in micromosaics aspired towards individual tesserae for every hair, very much as a painter would use brushstrokes. As the art form flourished and demand for micromosaics increased, mosaicists looked for ways to speed up the production process without sacrificing realism. In this example, the mosaicist Antonio Aguatti, one of the absolute masters of the art, has used countless tiny individual tesserae to achieve this magnificent depiction of an African leopard. Viewed under magnification, it is possible to discern the glass tesserae that form the light brown spots of the animal: each spot is unique, yet made using the same few colours. Some, but not all, spots include striped tesserae with two colours fused together.

Diameter 7 cm

Signed 'Aguatti' at lower right

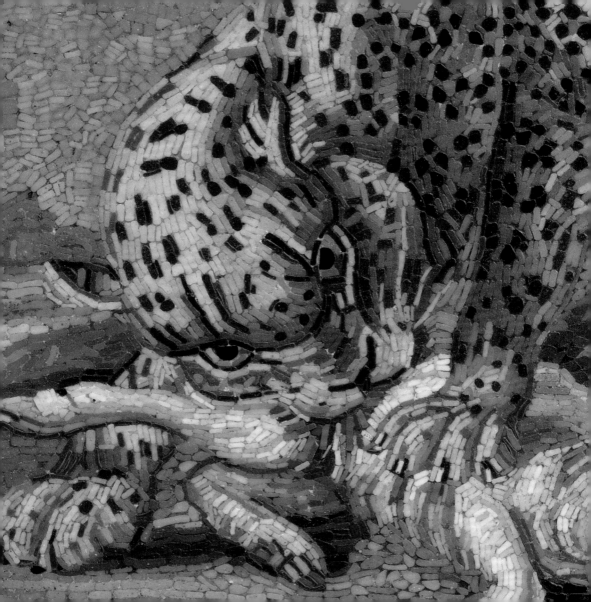

17

Leopard and kid after Johann Wenzel Peter

Attributed to Filipo Puglieschi (active first half 19th century), Rome, *c.* 1810

Not only does this mosaic showcase a different technique for creating fur in micromosaic, but it also expresses a different side of a leopard's nature. Filipo Puglieschi, to whom this work is attributed, specialized in gold box panels depicting animals in combat. Such images, though known in antiquity, had been revived by seventeenth-century artists such as Wenceslaus Hollar (1607–77). Their prints were still used by mosaicists as source material 200 years later. In this example Puglieschi has worked from a print after a painting by the Czech animal painter Johann Wenzel Peter (1745–1829), who worked for Pope Gregory XVI (1765–1846, pope from 1851) and died in Rome. Puglieschi created the leopard's fur and spots with rectangular and round tesserae. The spots on the animal's back look like petals because they consist of orange tesserae surrounded by a cluster of dark ones.

Diameter 7 cm

Strutting cockerel after Paulus Potter

Georgi Ferdinand Wekler (1800–61), St Petersburg, probably 1834

Naturalism was also the artistic aspiration in the handful of high-quality micromosaic workshops beyond Rome, as illustrated in this fine micromosaic produced in St Petersburg. Created by the leading Russian micromosaicist Georgi Ferdinand Wekler, this cockerel has a gleaming eye and confident strut. He is based on a painting by Dutch artist Paulus Potter (1625–54) and was acquired by Tsar Alexander I of Russia (1777–1825, reigned from 1801) in 1815. The almost uniform dark background provides a dramatic counterpoint to the vibrantly coloured feathers and coxcomb. Magnification reveals that Wekler made clever use of carefully set and unusually long, multicoloured, slender *malmischiati* tesserae. Virtually all the feathers as well as the comb were made using this method, creating an effect of life and movement.

Height 8.6 cm, width 6.9 cm

Signed 'W.' at lower right

Spaniel after Johann Wenzel Peter

Antonio Aguatti (died 1846), Rome, 1800–25
set in a snuffbox

In this signed piece, Antonio Aguatti, who also created a leopard plaque (no. 16), turned to a more domestic subject. Dogs, whether pets or working animals, were a hugely popular subject in small-scale work and feature in a good number of surviving micromosaics. Some subjects, such as this spaniel, were repeated time and again (compare no. 36) in varying degrees of quality and size, and for different uses. The spaniel remained in the repertoire for decades but Aguatti was probably among the first to depict one. Interestingly, while the grass is set using two-coloured glass pieces, Aguatti limited himself to single-coloured tesserae for the dog's coat, possibly to create contrast between plant and animal.

Snuffbox: width 7.6 cm, depth 5.7 cm, height 2.8 cm
Signed 'Aguatti' at lower centre

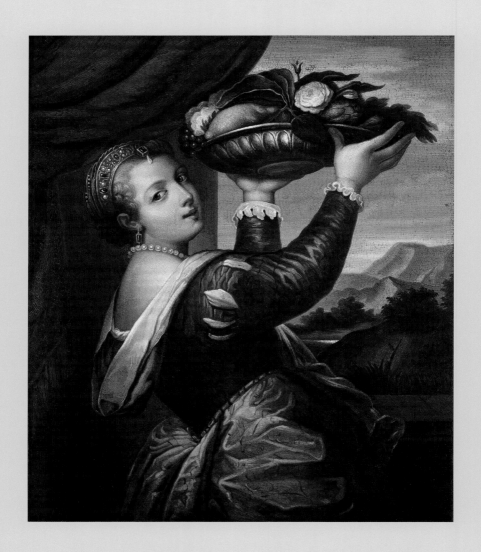

PORTRAITS AND PEOPLE

The earliest surviving naturalistic depictions of the human face in European art were created as funerary portraits in Roman Egypt between the first and third centuries AD. They represent the ancient tradition of producing an 'accurate likeness', as Pliny the Elder called it. A human face uses 43 muscles to express emotions, making it incredibly difficult to depict. And yet, micromosaicists, too, embraced this challenge. Despite the constraints of the medium, the artists included in this section have captured, to remarkable effect, something more than just the physical characteristics of the subjects. Most works in this genre are reproductions in miniature of famous portraits from Roman collections – the ideal vehicles for demonstrating how far the technique had developed in terms of execution and material. Depictions can be either highly idealized or uncensored authentic portraits.

no. 22

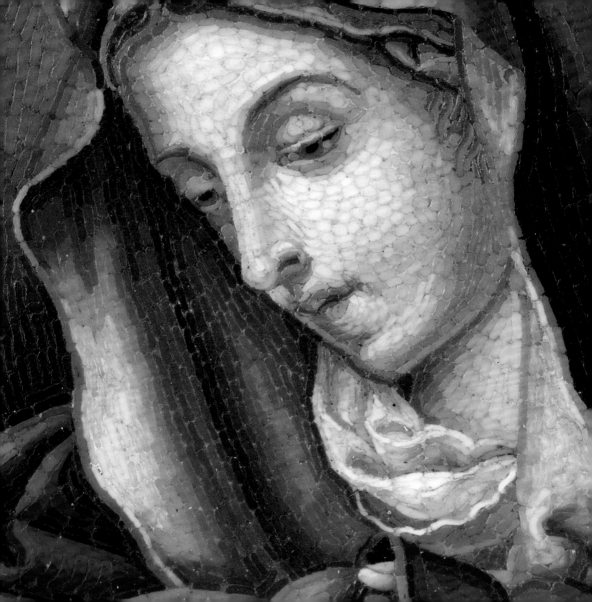

Virgin of the Thumb after Carlo Dolci

Luigi Moglia (active *c.* 1823–78), Rome, 1830–50
set in a frame

Mounted in a frame for wall hanging or presentation on a stand, this miniature Madonna is a portable prayer object rather than a piece of jewellery. It is a close copy of a widely reproduced iconic seventeenth-century composition known as the *Virgin of the Thumb*, historically attributed to Florentine painter Carlo Dolci (1616–86). Even in this minuscule reproduction, Luigi Moglia brilliantly retains the humanity and suffering of the Virgin. The virtuosity and care with which he created this utterly convincing face in minute pieces of glass is probably unsurpassed. His sparing use of multicoloured tesserae works to heightened effect, for example in the eyes, and even the spaces in-between are coloured to match. Remarkable depth is achieved through the arrangement of tesserae that range from rounded squares on the tonally fading cheeks to curved rectangles.

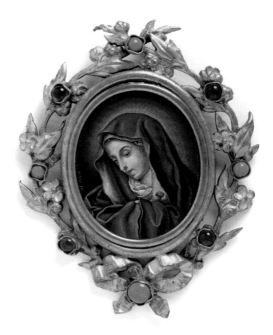

Height 4.1 cm, width 3.5 cm

Signed 'L. MOGLIA' at left border

Beatrice Cenci possibly after Elisabetta Sirani

Rome, 1820–50
set in a brooch

The Roman noblewoman Beatrice Cenci (1577–99) was executed at the age of 22 for her involvement in the murder of her father following a lifetime of tragic abuse. This micromosaic is based on an ideal, yet purely imagined, portrait. Long thought to be by Guido Reni (1575–1642), it has now been attributed to Elisabetta Sirani (1638–65). Percy Bysshe Shelley (1792–1822) saw the painting in Rome in 1819, around the time this mosaic was made. He declared himself haunted by the portrait and explored the story of Beatrice in his tragedy *The Cenci* (1819): 'It is most interesting as a just representation of one of the loveliest specimens of the workmanship of Nature. … The moulding of her face is exquisitely delicate.' Magnification reveals the making of the face: the artist left the interstices between the unevenly distributed tesserae brown and set the dark magnetic eyes with some four colours.

Brooch: height 4.3 cm, width 3.5 cm (shown right at actual size)

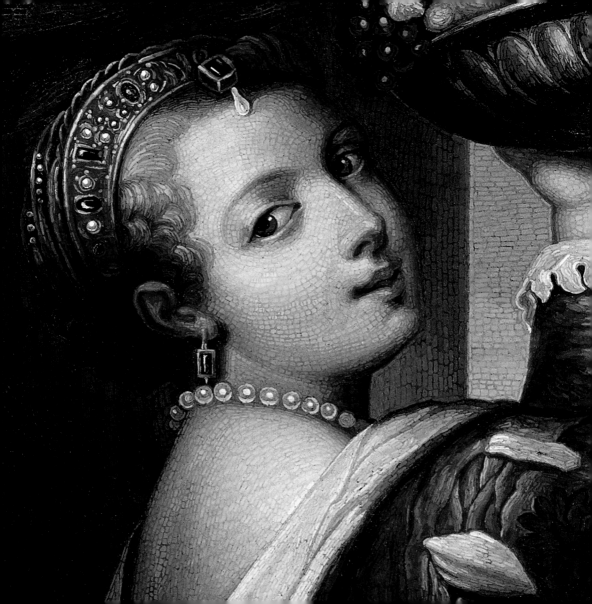

Girl with a bowl of fruit after Titian

Luigi Moglia (active *c.* 1823–78), Rome, *c.* 1830

Almost ten times wider than the jewel-like Virgin (no. 20), this mosaic was created by the same maker. Its individual tesserae are on the whole much larger than those used for his smaller objects, although reduced pieces are employed for the delicate features of the face. Painted in the mid-1550s and affectionately known as *Lavinia as Flora*, the painting on which the mosaic is based was until recently thought to be a portrait of Titian's (1488–1576) daughter. On the original, Titian deliberately blurred the edges on the face in a technique known as *sfumato*, meaning soft or hazy, and created an unforgettable image of a spirited girl with an ever-changing expression. Even a mosaicist of Moglia's skill was constrained by his materials and obliged to set his glass tesserae line by line. Thus while his version is charming, it is more static than the original painting.

Height 37 cm, width 30.5 cm; see also p. 64

Signed 'L[uigi]. MOGLIA F[ecit].' at lower right

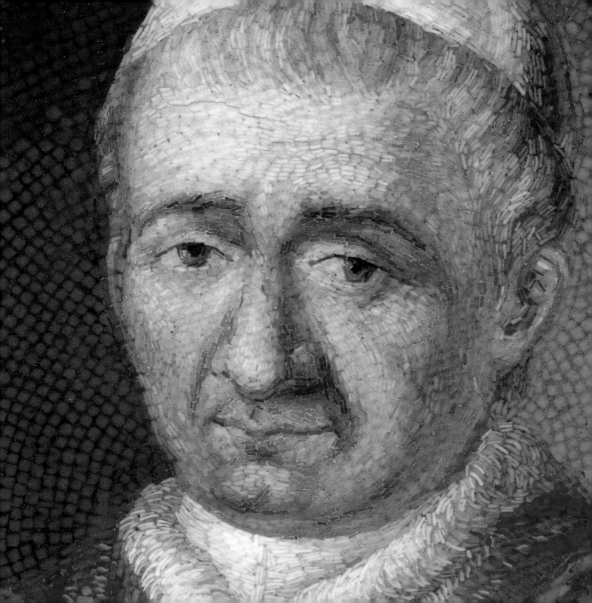

Pope Gregory XVI

Raffaelle Castellini (1791–1864), Rome, 1839

To this day, micromosaicists in the Vatican produce papal portraits as official gifts. In 1840, Pope Gregory XVI gave this portrait to clergyman Antonio Matteucci (1802–66), who managed the Vatican Mosaic Workshop's finances and administration at the time. Its form and composition are comparable to a chronological series of papal portraits at the Basilica of St Paul's Outside the Walls, Rome. Initiated by Pope Leo I (*c*. 400–61, pope from 440) in the fifth century AD, the series begins with St Peter. The church and portraits were devastated by a fire in 1823 (no. 26) and when the church was rebuilt it was decided to reinstate the series as mosaic portraits. The church was reconsecrated in 1855, and by 1876 the Vatican's mosaicists had finished their reproductions, including a portrait of their current pope. Since then the series has been continued by the Vatican mosaicists.

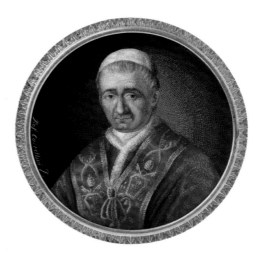

Diameter 8 cm

Signed 'Raf[faele]. Castellini f[ecit].' at left border

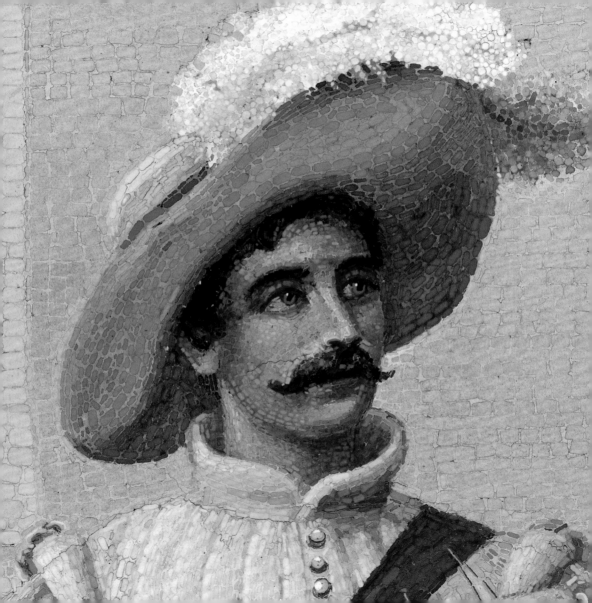

24
Cavalier

Luigi Tarantoni (active late 19th century), Rome, *c.* 1880

In addition to work for the Holy See, the mosaicists of the Vatican also produced pictures on commission or for general sale, including subjects such as this cavalier. Luigi Tarantoni specialized in this type of image, which shows a sole figure with a fantasy coat of arms in the upper-left corner on an otherwise almost uniform background. Bedecked in seventeenth-century dress, he could be straight from the pages of a novel such as *The Three Musketeers* (1840) by Alexandre Dumas (1802–70). The portrait-like nature of this image has parallels with the contemporary fashion for being photographed in historic costume, though it is not known if this is an actual portrait. Tarantoni has used paint, now partly discoloured, to make the face more convincing. The tesserae that depict the stone wall are arranged in a way that is comparable to those used in the backgrounds of the first generation of micromosaicists (no. 1).

Height 47.4 cm, width 27 cm

Signed 'Tarantoni. R[eferenda]. F[abbrica]. [di] S[an]. P[ietro].' at lower right

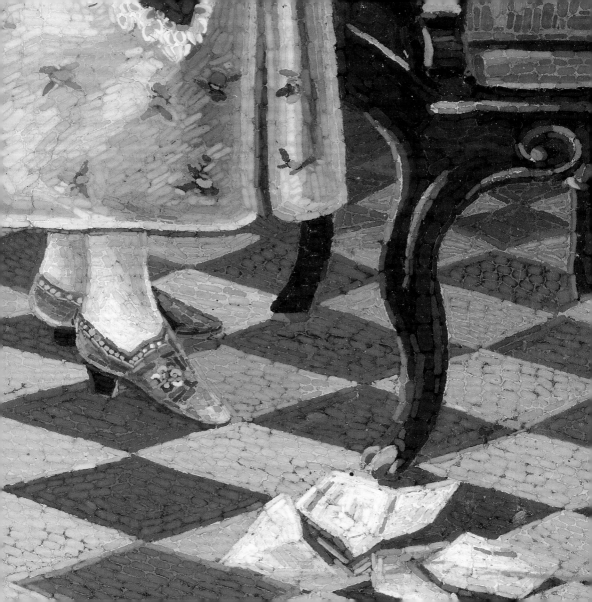

Genre scene

Rome or Venice, *c.* 1900

This romantic genre scene takes the viewer back to the eighteenth century. A gentleman approaches a young woman; a torn-up letter is lying at her feet. The rest is left to the viewer's imagination. This is a virtuoso piece in terms of mosaic making: the fairy-tale setting provides a showcase for the micromosaicist's ability to represent various materials in the chosen medium: the human figures in their fine silk clothes, skilfully depicted paintings, porcelain, glass and furniture. Ingeniously shaped tesserae, some of them combining three or more colours, reveal how much planning went into the production. The maker set out to deceive viewers into thinking the work a painting, luring them closer, to surprise them with the revelation that the work is a micromosaic.

Height 26.7 cm, width 18.7 cm

SOUVENIRS FROM ROME

Tourists were a key source of income for Roman artisans, including micromosaicists, and from the onset of the technique, micromosaics of varying quality were produced to cater for this clientele. Other mosaics in this volume might also have been souvenirs, yet the pieces brought together in this section are particularly interesting examples of Roman souvenir mosaics. Some of them were probably bought as gifts, while others might have been mementoes to remind travellers of their experiences. The available merchandise ranged from bespoke objects to readily available standardized plaques and jewellery and depicted iconic masterpieces or captured the famous sites of Rome. Apart from generic images that continued to be popular for decades, some micromosaics reference a particular event in the history of nineteenth-century Rome, such as the fire of St Paul's Outside the Walls in 1823.

no. 30 (detail)

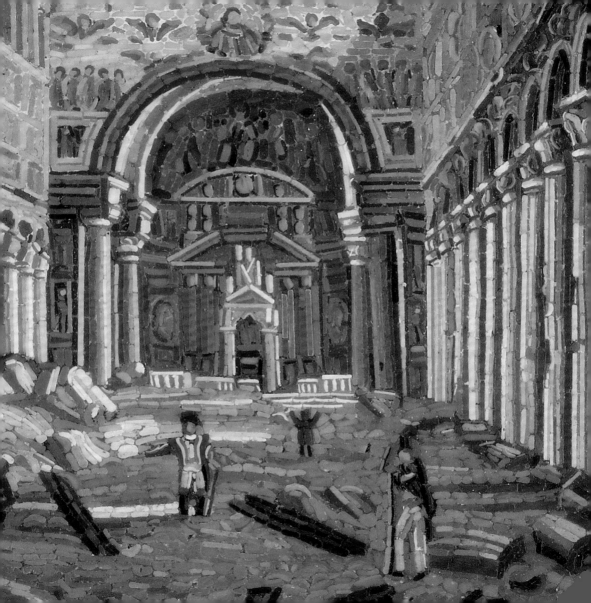

26
St Paul's Outside the Walls in ruins

Rome, 1823–5
set in a snuffbox marked Pierre-André Montauban, Paris

Few micromosaics can claim to be as topical
of their time as this view into the ruins of
the basilica of St Paul's Outside the Walls in
Rome. One of the oldest and most important
churches in the city, it was destroyed by a
catastrophic fire in July 1823. Though artist
Luigi Rossini (1790–1857) created a printed
view of the resulting devastation, the mosaic
is also an important record of the event,
showing, as it does, the ruins from a slightly
different angle. Several figures stand in the
rubble assessing the extensive damage to the
church that was to be swiftly rebuilt following
a papal appeal. The image cleverly depicts
mosaics within a micromosaic: at the far end
of the ruined building the apsis and altar
with their monumental medieval mosaic
decoration stand out in vibrant yellow. The
original mosaics were set against a golden
background, which was impossible to produce
in micromosaic.

Snuffbox: width 9.2 cm, depth 6.4 cm, height 2 cm

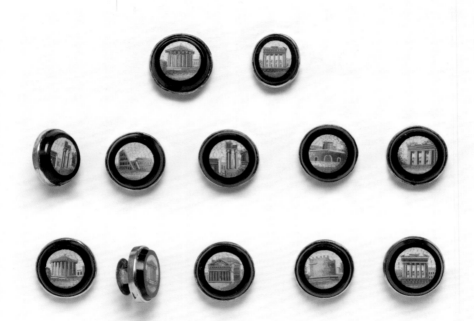

27
Sights of Rome

Rome, *c.* 1850
set into buttons and studs

In the 1800s, mosaic workshops producing
a limited range of the famous sights of
Rome and catering for all types of customers
clustered around the Spanish Steps in Rome.
This set of 10 buttons and two studs, which
would have adorned a gentleman's outfit,
were probably produced by one of these
workshops. The micromosaics are set directly
in prefabricated glass trays and were more
affordable than larger plaques and pictures.
There are two buttons with a view of the
Forum. By drawing out the most distinctive
shapes, and setting shadow and light with
just a few tesserae, the maker manages, even
on such a small scale, to render a clearly
identifiable picture of each famous site.
Perhaps more than any other piece in the
Gilbert Collection, these buttons and studs
celebrate mosaic making as an art of reduction.

Depicting various views of the Colosseum, the Temple of
Vesta (Tivoli), the Forum Romanum, the Arch of Tiberius,
the Pantheon, the Ponte Rotto ('Broken Bridge') and the
Tomb of Cecilia Metella

Buttons: diameter 1.5 cm each (shown left at actual size)

Aurora after Guido Reni

Rome, 1850–70
set in a bangle

Guido Reni's depiction of Dawn preceding
the sun god Apollo in his chariot, painted in
1614 on the ceiling of the casino of Palazzo
Pallavicini-Rospigliosi, is one of the most
famous frescos in Rome. Usually known as
L'Aurora, the fresco takes its name from the
figure of Dawn, Aurora in Italian, who dispels
night and darkness for the light of day. The
mosaic sits in a sturdy bangle with the large
inscription 'ROMA'. It is a bold souvenir of
which several examples are known, each
set with a unique micromosaic plaque. The
quality of the mosaics is, on the whole, not
as fine as that of many of the pieces included
in this volume. In this example, the surface is
unpolished and the maker has simplified the
composition and colour scheme to achieve
a recognizable image relatively quickly. To
this end, darker outlines border most of the
figure, such as the putto with a torch who is
a personification of the Morning Star.

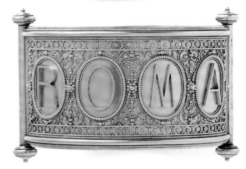

Bangle: height 6.4 cm, width 7.6 cm, depth 5.7 cm

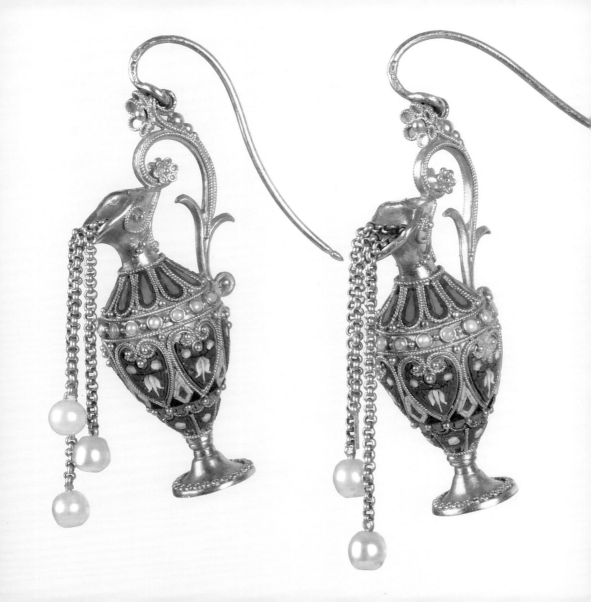

29
Ewer-shaped pendant and earrings

Rome, *c.* 1870

While ready-made micromosaic plaques were
mounted as or set in jewellery from the early
1800s, micromosaics only became an integral
part of the design of a piece of jewellery
during the last decades of the century.
Fortuitously, the new trend arrived just as
traditional plaques, and the boxes they might
have been made for, were going out of fashion,
potentially leaving makers unemployed. These
ewer-shaped creations were made as novelty
items. Minuscule golden chains with a pearl at
the end emanate from the spout of each tiny
ewer: dangling freely when worn, they give the
impression of water poured from the vessels.
The mosaic surfaces have been left unpolished
so that the tesserae sparkle as the pieces move
with the wearer.

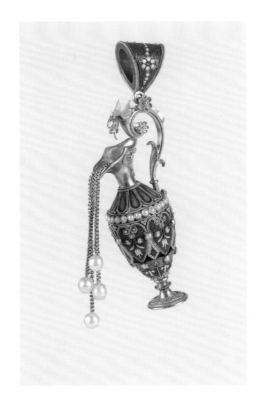

Pendant (right): height 7.8 cm including chain loop
Earrings (left): height 4.8 cm

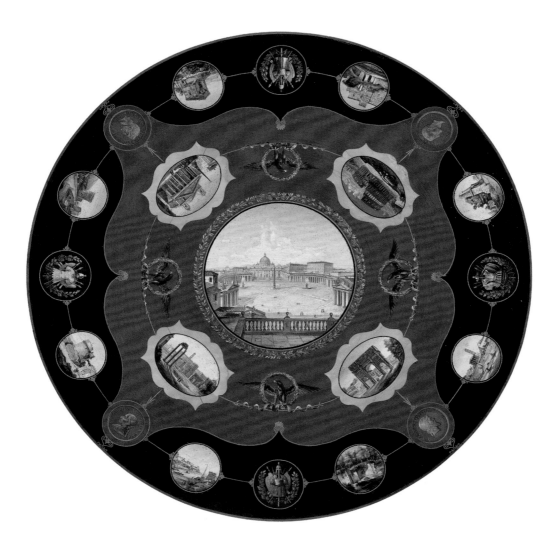

History of Rome

Cavaliere Michelangelo Barberi (1787–1867), Rome, 1845
set in a table completed before 1856

Michelangelo Barberi created micromosaics for the ruling families of Europe. This grandiose design, first conceived for the Irish nobleman Viscount Midleton (1791–1863), was repeated with minor variations and published in Barberi's visionary but humbly named album *Some Mosaics from the Studio* (1856). Barberi postulated that technical perfection in micromosaics was not an aim in itself but should be accompanied by a patriotic calling – a 'service to Rome' and Italy. 'The Four Ages of the History of the Eternal City' are the subject matter here, and are introduced by four portrait medals: 'a king, a consul, an emperor and a pope'. The fourth age, Christianity, is represented by the central view of St Peter's Square. The outer ring is a history of Rome, to be read anticlockwise, beginning with the view of the Palatine Hill as the legendary place of Rome's foundation.

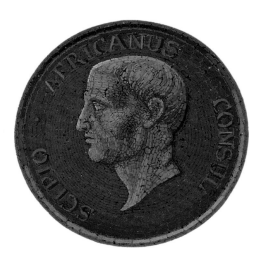

Table: diameter 114 cm, height 79.4 cm; see also pp. 2–3, 78, 139

Signed 'Cavalier M A Barberi / a Roma / Strada Rasella 148 anno / 1845' on marble cartouche; made for Lord William Ward (1817–85)

Monuments depicted (clockwise from top): inner circle: Colosseum, Arch of Constantine, Forum Romanum and Pantheon; outer circle: Tapejia Fortress, Tomb of the Horatii and Curatii, Temple of Vesta, Grotto of the Nymph Egeria, Mount Palatine, Tomb of Cecilia Metalla, Bridge of Luccano, and Temple of the god Rediculo

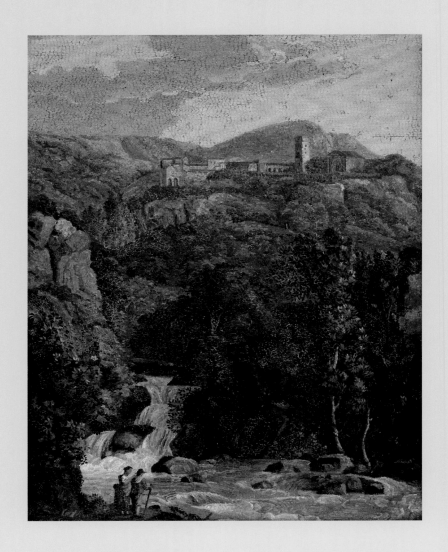

ITALY ENVISIONED

The dream of Arcadia, the byword for an imagined ideal landscape of shepherds and unspoilt nature, was frequently projected onto painted landscapes of the Italian peninsula. Naturally, micromosaic artists adopted the theme too. The French painters Claude Lorrain and Nicolas Poussin lived in Rome and were among the first to depict the landscapes of its surroundings on a large scale. Their work was a direct source for micromosaicists, such as Tomaso Calandrelli. In the nineteenth century, painters continued to come to Italy from northern Europe in search of its light and landscapes. Their work, too, became source material for micromosaicists. Some Italian artists, such as the Roman micromosaic maker Michelangelo Barberi, infused the vision of Arcadia with that of a politically united Italy.

no. 31

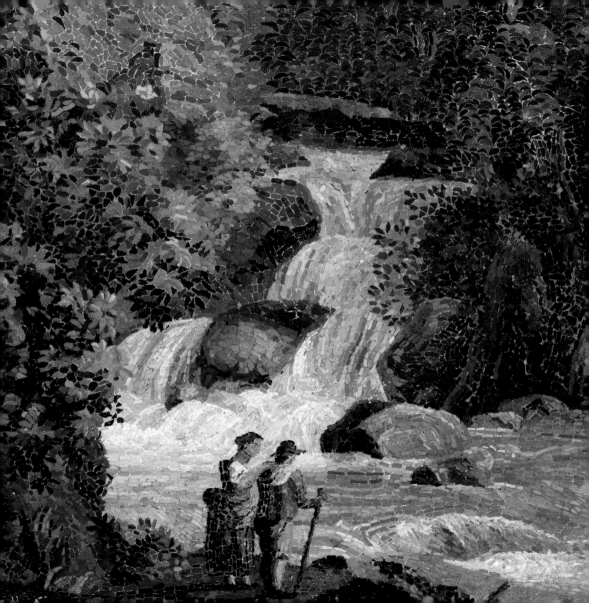

View of Tivoli

Giovanni Morelli (active 1800–25), Rome, 1820

The mountain town of Tivoli on the Aniene
River is famous for the ancient temples and
country retreats built by Emperor Hadrian.
It was in one of these that the *Doves of Pliny*
mosaic (p. 6), which was to become such an
inspiration for mosaicists, was discovered in
1737. The surrounding countryside, celebrated
for its dramatic waterfalls, was painted
by generations of landscape artists. This
micromosaic depicts Tivoli, which can be
seen in the hazy background, rather than the
more popular view of the temples (no. 1).
Two peasant figures in the foreground
complete the scene, which, despite depicting
an existing location, has a timeless and rather
idealized quality.

Height 38.7 cm, width 29.8 cm; see also p. 90

Signed 'Gio.Morelli Fece 1820' at lower left

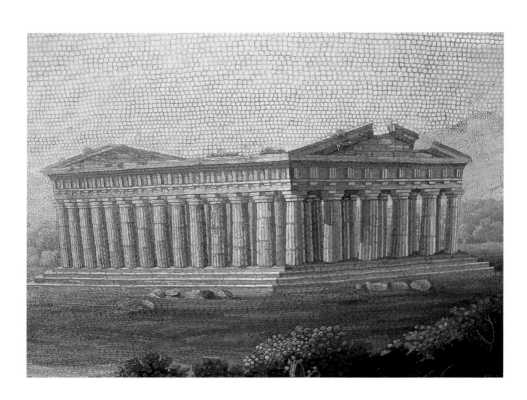

Ruins of Paestum after Fyodor Matveyev

Gioacchino Rinaldi (active 1800–25), Rome, *c.* 1830

The magnificent composition (p. 137) from which these detailed images are taken records another important stop on the Grand Tour: Paestum with its imposing ruins. Rinaldi used artfully shaded, slender tesserae for the columns, in contrast to the even squares of the sky. Among the largest works in micromosaic, it is derived from a painting by one of the first Russian landscape artists, Fyodor Matveyev (1758–1826). After training in St Petersburg, he settled in Italy in 1779. At least six micromosaics of his work exist, including a later version by Etienne Moderni, which fills the space above a mantelpiece in the Gold Drawing Room in St Petersburg's Winter Palace. The room, resplendent in gold, was decorated between 1838 and 1841 by Alexander Bruillov (1798–1877) for Empress Maria Alexandrovna (1824–80), who married the future Tsar Alexander II (1818–81) in 1841.

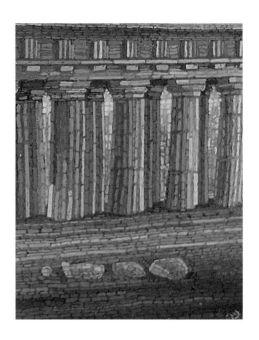

Height 49 cm, width 167 cm

Signed 'G. V. Rinaldi' at lower right

Flora of the Two Sicilies

Cavaliere Michelangelo Barberi (1787–1867), Rome, *c.* 1850
set in a table

In 1845–6 Tsar Nicholas I and his family
visited the Kingdom of the Two Sicilies, the
largest of the Italian states. This tabletop is a
personal record of their tour, depicting not
only the famous sights, but also the stunning
flora typical of the regions visited. The names
of both are given on a micromosaic band,
imitating a textile ribbon: one can read
Taormina, Palermo, Tindari, Pompeii, Naples
and Paestum. At the centre of the piece,
suspended in the sky, is the profile of Nicholas
I's daughter, Grand Duchess Olga (1822–92).
According to Barberi she was depicted on
her father's request 'inside a star obscuring
the sun'. She met her future husband, Crown
Prince Charles of Württemberg (1823–91,
reigned from 1864), during this trip. The top
sits in an elegant stand, designed and made in
St Petersburg. It is constructed as a rotating
table so that all scenes can be seen without
the viewer having to move around it.

Table: diameter 104 cm, height 79.4 cm

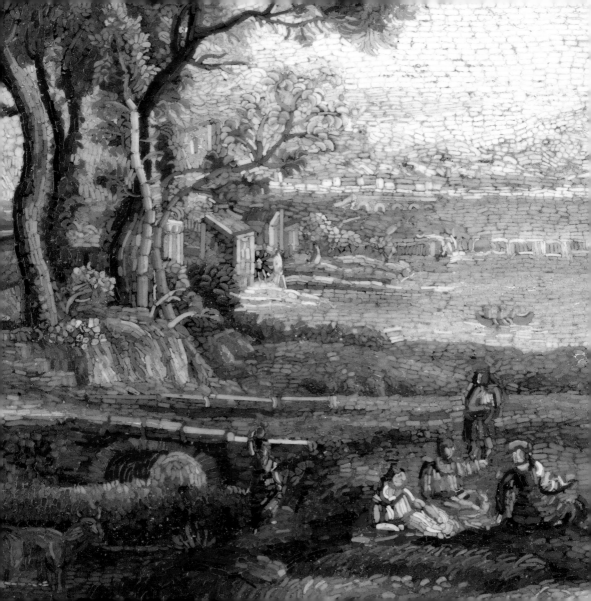

34
Landscape with a mill after Claude Lorrain

Tomaso Calandrelli (active first half 19th century), Rome, *c.* 1825
set in a snuffbox

This detailed pastoral landscape with a
mill was first imagined by Claude Lorrain
(1600–82), who painted two versions of the
scene in Rome around 1647. Although the
painting depicts the biblical story of Isaac
and Rebecca, the Roman countryside is the
artist's real interest. Mosaicist Calandrelli
copied the Palazzo Doria Pamphilij's version
of the painting, reproducing the colouring
and shape of the clouds, trees, mountain
range and dancers. Landscapes like Lorrain's
are a common theme for rectangular
micromosaic plaques for snuffboxes. Lorrain
was famed for his precise depictions of
nature, painting virtually every leaf on a
tree with clear brushstrokes. This precision
would have helped mosaic artists translate
his work into mosaic. Unusually, the sides of
the box are also decorated with slim strips of
micromosaics, featuring flowers.

Snuffbox: width 9 cm, depth 6.4 cm, height 2 cm

Signed 'Calandrelli.' at lower left

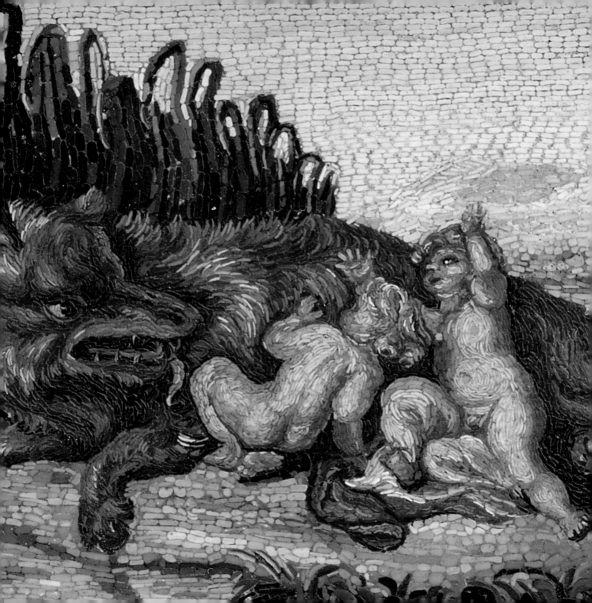

Romulus and Remus after Peter Paul Rubens

Rome, *c.* 1825
set in a bracelet

The founding myth of the city of Rome is depicted on this micromosaic. Abandoned on the banks of the River Tiber, the twins Romulus and Remus were suckled by a she-wolf before being adopted by the shepherd Faustulus. According to legend, Romulus later killed his brother and went on to found Rome, becoming its first king. The famous depiction of this myth by Peter Paul Rubens (1577–1640) inspired copies in many sizes, including this bracelet. It is a good example of how mosaic plaques were set as jewellery: the mosaic is framed with small strips of malachite and sits in a slim octagonal metal tray. The tray is in turn set in a gold frame that is held in a bracelet of woven human hair. Such hairwork, sometimes made at home using the hair of a loved one, was particularly fashionable in the 1800s.

Height 3.9 cm, width 4.8 cm

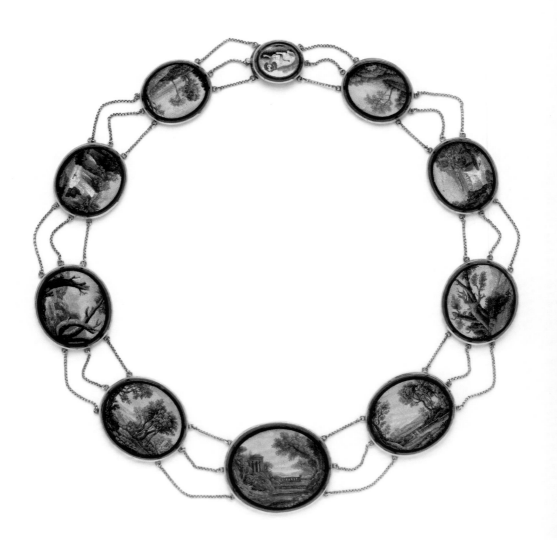

Landscape views and spaniel

Possibly Antonio Aguatti (died 1846), Rome, 1810–50
set in a necklace

Ten oval mosaics, each set in a vibrant blue
cut-glass tray, are linked with gold chains to
form this necklace. Most likely designed as
a set, each scene is paired with another on
the opposite side of the necklace. Nine show
idealized Roman landscapes with foaming
waterfalls and weather-beaten trees, variations
of themes found on prints after works by
seventeenth-century painters Claude Lorrain
and Nicolas Poussin (1594–1665). These
landscapes are devoid of human presence,
inviting the viewer to insert themselves into
the picture. The mosaic at centre top shows
a spaniel, illustrated with just a few pieces
of cleverly made multicoloured tesserae to
capture the essence of its eyes and coat. For
comparison see Antonio Aguatti's version
(no. 19).

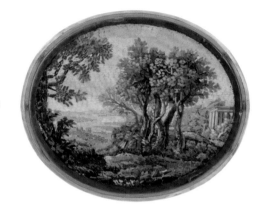

Necklace: length 46 cm, largest plaque: height 3.7 cm,
width 4.1 cm

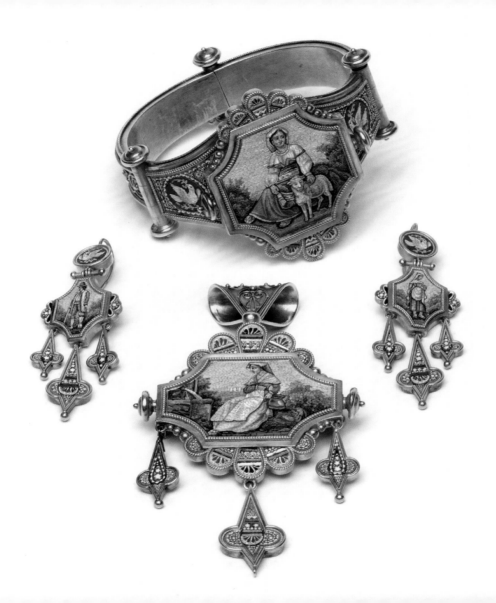

37
Figures in regional costumes

Rome, *c.* 1870
set in a suite of jewellery

Tourists venturing into the Italian countryside in search of natural beauty would also encounter its inhabitants. These mosaics show single figures in traditional dress against greenery and blue skies. The two larger plaques evoke a pastoral atmosphere: on the bangle, a young woman in an apron is accompanied by a lamb, while the figure on the pendant sits at a fountain, jug in hand. The images reflect an increased interest in traditional dress and costumes, which gave rise to the publication of albums of drawings, such as *Roman Costumes Drawn from Nature* (1820) by Bartolomeo Pinelli (1781–1835) and Charles Hullmandel (1789–1850). The style of the goldsmiths' work is comparable to the bangle set with a mosaic after Guido Reni's Aurora (no. 28). These mosaics, too, are unpolished.

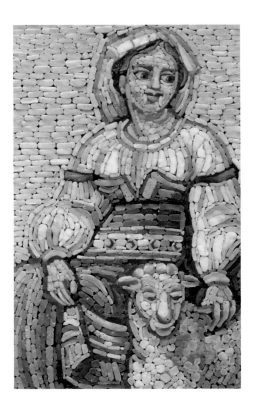

Bangle: height 5 cm, diameter 6 cm (maximum)
Earrings: height 6.5 cm, width 2.2 cm each
Pendant: height 10.2 cm, width 5 cm

Young harvester

Porta Constant Mosaic Factory, possibly Rome, *c.* 1890

A label on the back of this comparatively late piece identifies the Porta Constant Mosaic Factory as its place of production; it is the only known mosaic with such a label, and is possibly after Antonio Jaspe y Moscoso (1856–87). Less nuanced than most mosaics in this volume, it exhibits a bold poster-like quality. The figure, shown in profile and with an expression of utter concentration on her face, wears regional dress and stands in a field with an Italianate view, including the ruins of an aqueduct, behind her. Even though this composition combines the same elements seen in other mosaics of the Roman countryside – regional costume, wide skies above mountains, Roman ruins and young beauty – there is no trace of romantic idealization in the figure. Instead she stands in defiant determination.

Height 23.5 cm, width 15.2 cm

Labelled at back of frame: 'Porta Constant Mosaic Factory'

BEYOND ROME

Micromosaics made an international impact soon after their introduction. Though Rome remained unrivalled in its number of workshops, makers and their ambitions, the new technique was exported to other Italian cities, notably Naples and Venice, and then to northern Europe. In Russia, the tsars adopted micromosaics as an imperial medium. One of the greatest micromosaicists, Georgi Ferdinand Wekler, who first trained as a glass painter in Moscow, learnt micromosaic making from Roman master Domenico Moglia (1780–1863). In 1822 Wekler was appointed master of mosaics at the Royal Academy of Art in St Petersburg. The pieces selected for this section highlight characteristics of the different centres of production. They also show that in spite of ever-increasing knowledge and archival research it is still not always possible to attribute a micromosaic to one particular place.

no. 40 (detail)

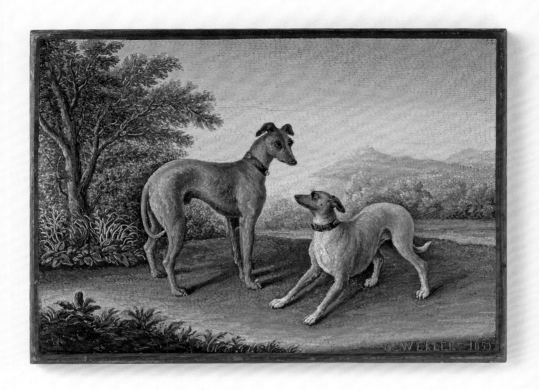

Two dogs

Georgi Ferdinand Wekler (1800–61), St Petersburg, 1853

By 1853 an awe-inspiring range of colours in opaque glass was available to micromosaicists, allowing this generation of makers to pursue a new ambition. 'Painting in glass' was no longer the primary challenge; instead, mosaic paintings should not only convince in their technical genius, but should also be contemporary works of art and original designs. Georgi Ferdinand Wekler was the leading micromosaicist in Russia, yet it seems he could not entirely let go of Italian imagery. These two dogs, probably Italian greyhounds, a breed very much in fashion at the time and also seen in photographs of the daughter of Tsar Nicholas I, Grand Duchess Olga of Russia, Queen of Württemberg (1822–92), appear to be set in a landscape that might easily belong to an Italian mosaic (no. 33).

Height 10.8 cm, width 14.6 cm

Signed 'G. Wekler 1853.' at lower right

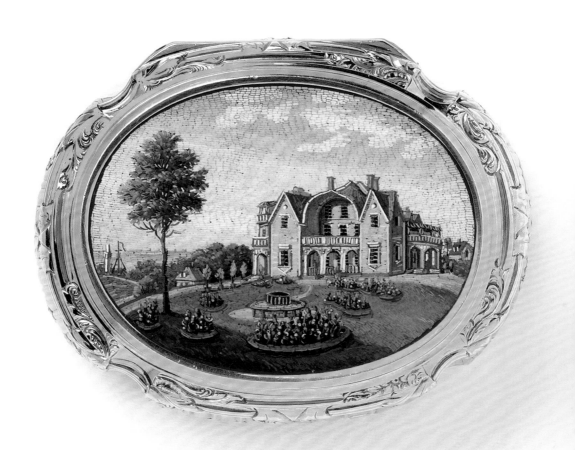

Cottage Palace in Alexandria Park

Attributed to Georgi Ferdinand Wekler (1800–61), St Petersburg, 1843–50
set in a snuffbox

This diminutive mosaic plaque, set in a gold box, depicts the summer residence of Tsar Nicholas I at Peterhof, outside St Petersburg. Surrounded by a landscaped garden, this villa offered the imperial family a home away from formal life at court. The design of the building was inspired by a romantic interpretation of a British cottage. Wekler has chosen shapes and colours that evoke the welcoming character of the yellow villa as the sky turns purple over the Gulf of Finland in the distance. Circular flower beds lead the eye to the curved arches and roof of the cottage, which is echoed by the shape of the mosaic and even the box itself. This comparatively little box has the character of a treasured and personal souvenir, possibly made for a member of the imperial family.

Snuffbox: width 6.3 cm, depth 5 cm, height 3.2 cm;
see also p. 108

Icon of St Nicholas

Probably St Petersburg, *c*. 1858
set in a gilded silver frame marked Sazikov, Moscow or St Petersburg, 1858

While icons of St Nicholas are common in Russian Orthodox homes, only a few micromosaic versions are known, including one in a mosaic triptych that has been attributed to Russian micromosaicist Georgi Ferdinand Wekler. The silver frame of the mosaic shown here was made in 1858. The mosaic portrays St Nicholas the Wonderworker, a fourth-century bishop in vestments of the Orthodox Church, with a pendant around his neck depicting the Virgin Mary. His right hand is raised in blessing and he holds a Gospel in his left. Saints depicted in icons are used for veneration in the Eastern Church, following long-established conventions. Here, even within the confines of the traditional imagery, the mosaicist has managed to convey the humanity of St Nicholas through his slightly tousled hair and beard, which contrast with his rich vestments.

Height 18.1 cm, width 13.7 cm

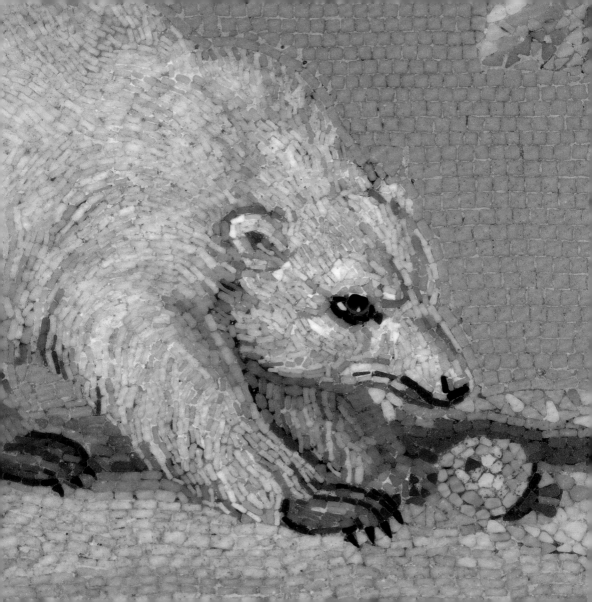

42

Bear and dog

Russia or Rome, 1815–30
set in a snuffbox

Russian mosaicists usually either trained in
Rome or learned from Roman masters, which
sometimes makes the attribution of work to
either place difficult, as in the case of this box,
set with six micromosaic plaques. The main
mosaic on the lid is a version of a larger and
more detailed plaque set in a table made for
the State Hermitage, St Petersburg, which
bears the signature of Giacomo Raffaelli and
the date 1826. Ancient floor mosaics depicting
fights between bears and dogs are known, but
this plaque captures the moment just before
the action: readying himself to defend his
luscious apple, the bear eyes the stealthily
approaching dog. Set against an even blue-grey
background, the two animals appear to float
on a cloud-like patch of grass, a convention
taken from Roman floor mosaics.

Snuffbox: width 8.7 cm, depth 5.3 cm, height 2.4 cm

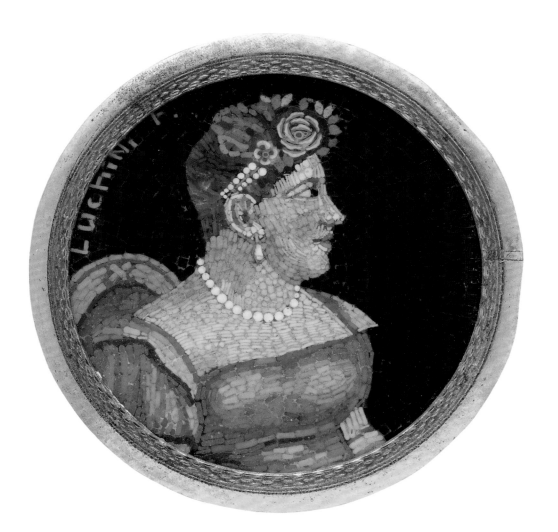

43
Pair of miniature portraits

Giovanni Battista Luchini (active first half 19th century), Naples or Rome, 1810–30

These two miniature portraits are small enough to be set in a locket or snuffbox lid. Possibly depicting King Francis I of the Two Sicilies (1777–1830, reigned from 1825) and his second wife Queen Consort Maria Isabella (1789–1848), they are unique. Portrait miniatures were generally less fashionable in Italy than in northern Europe, although Naples is an exception, since miniature painting was taught at its art academy during the early 1800s. Giovanni Battista Luchini (or Lucchini), also recorded in Rome, was director of the mosaic studio at Naples between 1811 and 1814, and these might be examples of work produced in this workshop. The density of the mosaic and the size of the tesserae are comparable to the two works that follow (nos 44; 45).

Diameter including frame 3.2 cm each (shown right at actual size)

Signed 'LUCCHINI F[ecit.]' at rim

The Judgement of Solomon

Ferdinando Scalabrino (active first half 19th century), Naples, 1818

This Neapolitan micromosaic is quite clearly different from Roman micromosaics of the same period. Though the colour range is fairly limited, Scalabrino has played with triangular and round tesserae to create different patterns. The picture shows the Judgement of Solomon after a painting (2 m wide) that has been attributed to the workshop of Peter Paul Rubens (1577–1640). Painted about 1617, it was circulated in print soon after this date. Because a monochrome print was used as source material for this mosaic, the colour scheme differs from the original. The mosaic repeats the glances and gestures used by Rubens to tell the story of two mothers claiming the same baby as their own. When Solomon orders the newborn to be cut in half, only the true mother loved unconditionally enough to give up the child to save its life.

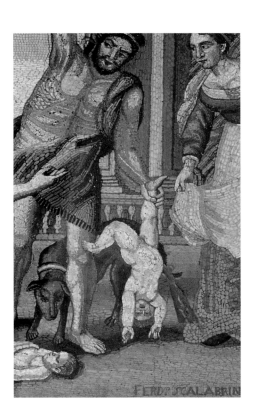

Height 22.9 cm, width 33 cm

Signed 'Ferdinando Scalabrino fecit in Napoli 1818.' at lower right

The oath of Catiline after Salvator Rosa

Naples or Rome, *c*. 1800–20

Like the previous mosaic (no. 44), this piece follows a monochrome print after a famous baroque painting, in this case by Salvator Rosa (1615–73). The measurements of the mosaic are quite close to those of some print versions, including an engraving published in Florence in 1798, suggesting that the design of the mosaic was directly transposed from a print. Similarities to Ferdinando Scalabrino's copy after Peter Paul Rubens, include the limited colour palette, the overall size and the background wall that is set using rectangular tesserae, creating strong vertical lines in contrast to the even grid of some early Roman work (no. 1).

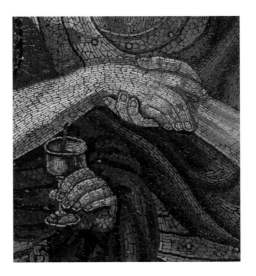

Height 20.6 cm, width 38.7 cm

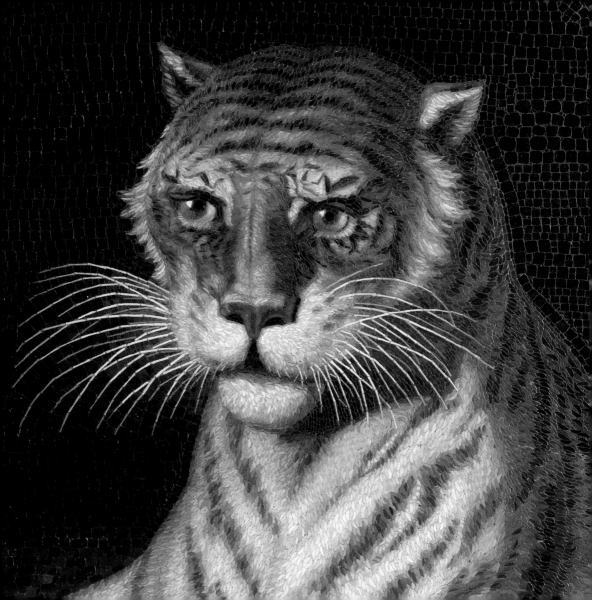

Tigress after George Townley Stubbs

Decio Podio (born *c*. 1860), Venice, 1880–1910

Venice and its region remain an important centre for mosaic production to this day. Yet, it seems that the city did not play a role in the nineteenth-century invention and rise of micromosaics. It was only after Venice had become part of the newly established Kingdom of Italy in 1866, and its economy had recovered, that mosaic expertise, which in the sixteenth century had been brought from Venice to Rome, returned to Venice. One of the finest manifestations of this revival is this stunning mosaic of a tigress by Decio Podio. It is one of the most convincing imitations of a painting in mosaic. At least two versions of the tigress are known today, both probably based on a popular masterpiece by the British artist George Stubbs (1724–1806) from around 1780. Here, Podio has contrasted different sizes and shapes of tesserae to create miraculously smooth colour transitions.

Height 50.8 cm, width 66 cm

Signed 'DECIO PODIO VENEZIA' at lower left

A
NEW ERA

Micromosaics were an important Italian export throughout
the nineteenth century, but as the century came to a close
the world had changed significantly since the days of their
genesis. When micromosaics were first invented, Italy had
been a cluster of states; now it was politically united. The first
micromosaics were perceived as sophisticated virtuoso pieces that
enabled elite visitors to take a vision of Roman antiquity home
from their travels. Over the century, new themes had become
fashionable, and from 1900 new influences and a hunger for more
contemporary styles and larger works prevailed. Most importantly
the increasingly widespread use of photography that emerged at
this time prompted different approaches to realism. These ranged
from works that attempted to imitate photographs through to
large, roughly set and unpolished mosaics that were outright
rejections of any attempt at realism.

no. 47 (detail)

View of St Mark's Basilica

Venice, c. 1902–10

The Photochrom process was perfected in the 1880s, allowing the addition of colour to black-and-white photography. As a result, photographic postcards became fashionable. This quantum leap in technology changed the viewer's perception of what was considered a realistic picture. Now, instead of competing with painted surfaces, the new benchmark for mosaicists was photorealism. This micromosaic is an extraordinary attempt at photorealism through the use of the most complex tesserae to be found in micromosaics. The capitals of the columns of the portico and the mosaic faces on the building's façade were created by cutting tesserae from glass canes. Known as *murrine*, they consist of layers of coloured glass fused into a single cane. When cut into cross-section they reveal a pattern or face. Thanks to these small prefabricated pieces, the further the viewer moves from the image, the more it resembles a photograph.

Height 18.7 cm, width 26.4 cm; see also p. 126

Interior of St Peter's Basilica after Romeo Cavi

Augusto Moglia (active second half 19th century), Vatican Mosaic Workshop, Rome, 1899

This glimpse into the vast interior of St Peter's Basilica, Rome, is dated 1899, making it contemporaneous with Decio Podio's Tigress (no. 46). While Podio brought micromosaic techniques to Venice, Augusto Moglia was working within the Vatican Mosaic Workshop, benefiting from more than a century of makers' experience and a vast array of colours. The source for this mosaic is a watercolour by little-known Romeo Cavi (1862–1908), perhaps painted as a design for Moglia's work. It shows the view from the figure of St Peter to the main altar of the basilica, including some of the Renaissance mosaic decoration of the dome. A women with a baby and a boy stands in front of St Peter and looks out of the mosaic directly at the viewer. The pastel colour scheme presents the interior in a soft and even light. It is an intimate, welcoming picture of a monumental, dramatic building.

Height 73.7 cm, width 50.8 cm

Signed 'A. Moglia / 1899 / R.F.S.P.' at lower right

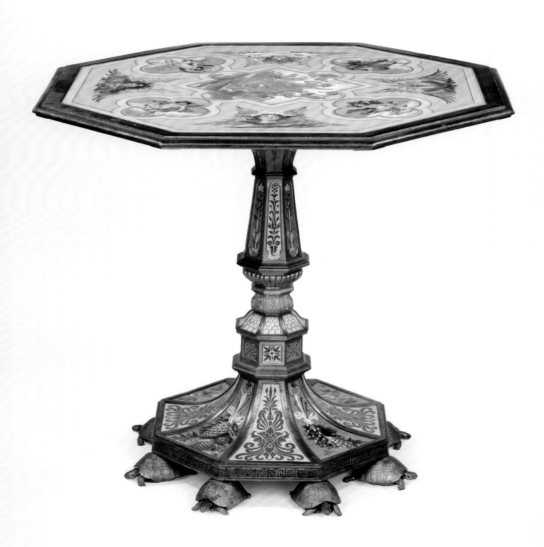

49
Apollo with the Seasons and Elements

Probably Rome, *c*. 1900
set in a table

This highly unusual piece exemplifies the
Art Nouveau style that emerged around 1900
in centres such as Paris, Brussels and Prague.
It showcases the makers' ability to adopt the
latest fashion and is the only micromosaic in
this style in the Gilbert Collection. It shows
the sun god Apollo at the centre, surrounded
by personifications of the Four Seasons as
winged children, and the Four Elements –
earth, water, fire and air – as winged faces.
The depictions reflect the work of Czech
painter Alfons Mucha (1860–1939) and Belgian
graphic designer Henri Privat-Livemont (1861–
1936). The central column of the table is also
decorated in mosaic, and includes trophies of
plants corresponding to the Four Seasons. By
whom and where the mosaics were designed
and made remains a mystery.

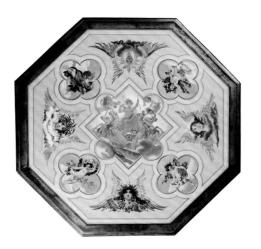

Table: diameter 94 cm, height 78.7 cm

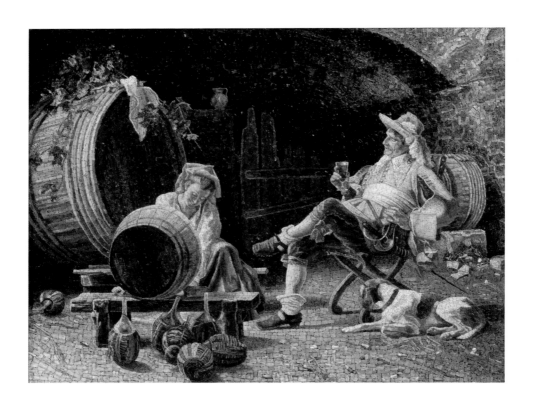

Tavern scene after Francesco Vinea

Probably Vatican Mosaic Workshop, Rome, before 1967

This twentieth-century piece was purchased from the Vatican Mosaic Workshop in 1967. It is a copy of a genre scene by Francesco Vinea, whose paintings Italian man of letters Angelo de Gubernatis (1840–1913) described as 'well-designed witticisms' and 'costume scenes preening with grace and trivial levity'. The paintings, he said, 'fade from memory like iridescent soap bubbles flit from our vision'.[1] Fade from memory the paintings might, but these 'bubbles' were re-created in a heavyweight mosaic technique for a twentieth-century audience. This piece is not meant to be mistaken for a painting; on the contrary, the unpolished, relief-like surface and the size of the tesserae are a complete departure from traditional micromosaic techniques. Another mosaic of the painting was made in 2002 by Roberto Grieco (born 1956), mosaic maker and scholar.

1 Gubernatis, Matini, 1889, pp. 549–50

Height 48.3 cm, width 63.5 cm

GLOSSARY

Andamento
Italian for 'course, progress'; the flow and direction of lines and clusters of tesserae and, in addition to the choice of colour and material, a crucial means of influencing the overall appearance of the mosaic; in micromosaics comparable to a painter's brushstroke with, at times, distinctive hands of various mosaicists or workshops.

Composition
Here, the original design or visual source material after which a micromosaic is created.

Copy
In this context, a detailed repetition of an existing original image without significant changes to the original artist's composition.

Direct method
Mosaic technique where tesserae are fixed directly on the base with an adhesive or embedded into a mastic; the only mosaic technique until Renaissance times and the only technique used for micromosaics.

Emblem mosaic
In antiquity a mosaic set on a slab of stone, and hence portable.

Gesso
Italian for 'gypsum'; mixture of plaster of Paris and adhesive.

Giornata
Italian for 'day', also meaning 'a day's work'; the surface area an artist or craftsman can complete in one session and which therefore is prepared accordingly, for example by applying gesso to the support.

Grouting
The process of filling the spaces between mosaic tesserae with material, in a normal mosaic often a mixture based on plaster of Paris; in micromosaics pigmented beeswax is common; the grout could be coloured to match the colour of the tesserae around it.

Indirect method
Mosaic technique where tesserae are fixed on a temporary support upside-down, often in a workshop, before permanent installation in situ.

Interstices
The spaces between the individual tesserae.

Malmischiato
Singular *malmischiati;* Italian for 'badly mixed'; here a rod of opaque glass, usually prepared by fusing two or more colours together to create a layered cane. Such tesserae were used to speed up production and increase the painterly effect of a finished mosaic.

Mastic
Putty-like, adhesive paste used for setting a mosaic; often ground travertine, lime and linseed oil in micromosaics.

Micromosaic
The term 'micromosaic' was allegedly coined by Sir Arthur Gilbert to describe mosaic pictures made from minuscule pieces of glass (see Tesserae), known in Italian as *mosaico minuto.*

Millefiori
Italian for 'thousand flowers', singular *millefioro*; multicoloured glass canes (see *Murrine*), with individual colours fused together to show a blossom or flower in cross-section.

Miniature
Here, a small and often very fine, portable picture.

Mosaics
Pictures made of small pieces known as tesserae, regardless of the material used (see Tesserae).

Murrine
Singular *murrina*; miniature patterns or figural images in glass, including faces and flowers (see *Millefiori*), as an intermediate product of mosaic and vessel production; made by fusing several colours as a cane (see *Smalti filati*) and revealed when the cane is cut into cross-sections; allegedly the term was first introduced by a priest on Murano island in the Lagoon of Venice who wanted to promote the local glass industry.

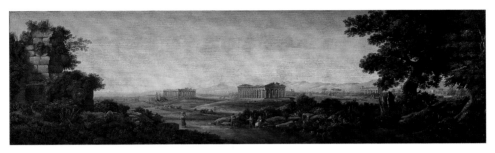

no. 32

Pizze
Singular *pizza*; in the glass industry a piece of coloured glass (see *Smalti*) in the shape and size of the Italian signature dish, used for storing the material until it is used in mosaic making.

Plaster of Paris
Gypsum plaster, named after a deposit in the Montmartre area of Paris, but known already in antiquity.

Polishing
Finally, the micromosaic surface is evened out using a piece of lead; then pigmented beeswax is applied to conceal the interstices; a polish, for example with beeswax, could conclude the process. Some makers opt for an unpolished surface for a textured finish.

Smalti
Italian for 'enamel', singular *smalto*; opaque coloured glass.

Smalti filati
Italian for 'enamel canes'; canes or rods of opaque glass that are heated until malleable so that individual tesserae can be cut off.

Snuffbox
A type of box with a tight-fitting lid developed in the seventeenth century to hold powdered tobacco known as snuff; such boxes were also used as diplomatic and personal gifts and often fitted with small precious plaques, including portrait miniatures and micromosaics.

Support
In this context, the panel or tray that holds the micromosaic; depending on size and date, stones, metal (from brass to iron) or glass were used; also known as *cassina* in Italian.

Tesserae
From Latin, meaning 'cube, square', originally from Ionic Greek *tesseres*: 'four'; singular tessera; the smallest unit in mosaic making, independent of material and shape; in micromosaics a piece of opaque glass between 0.5 and 5 mm in length and width.

BIBLIOGRAPHY AND FURTHER READING

Avery, Charles, and Arthur Emperatori, *Mosaics from the Gilbert Collection: Summary Catalogue* (London 1977)

Cavaliere Barberi, Michelangelo, *Alcuni musaici usciti dallo studio* (Rome 1856)

Bostock, John, and Henry T. Riley, *The Natural History of Pliny. With Copious Notes and Illustrations*, vol. 6 (London 1857)

Eaton, Charlotte, *Rome in the Nineteenth Century*, 3 vols (Edinburgh 1820)

Elias, Norbert, Kitschstil und Kitschzeitalter. Mit einem Nachwort von Hermann Korte (Münster 2004)

Gabriel, Jeanette Hanisee, *Micromosaics: Private Collections* (Los Angeles 2016)

Gabriel, Jeanette Hanisee, *The Gilbert Collection: Micromosaics. With an introduction by Anna Maria Massinelli and essays by Judy Rudoe and Massimo Alfieri* (London 2000)

Goethe, Johann Wolfgang von, *Italian Journey*, trans. W.H. Auden and Elizabeth Mayer (London 1970)

González-Palacios, Alvar, *The Art of Mosaics: Selections from the Gilbert Collection* (Los Angeles 1977)

González-Palacios, Alvar, and Steffi Röttgen, *The Art of Mosaics: Selections from the Gilbert Collection*, rev. edn (Los Angeles 1982)

Grieco, Roberto, *Micromosaici romani: Roman micromosaic* (Rome 2005)

Grieco, Roberto, and Arianna Gambino, *Roman Mosaic: L'arte del micromosaico tra '700 e '800* (Milan 2001)

Guattani, G.A., *Memorie enciclopediche sule antichita e belle arti di Roma* (Rome 1806–19)

Gubernatis, Angelo de, and Ugo Matini, *Dizionario degli artisti Italiani viventi. Pittori, scultori e architetti* (Florence 1889)

Habsburg-Lothringen, Géza von, *Gold Boxes from the Rosalinde and Arthur Gilbert Collection: Superb Examples of Goldsmiths' Art* (Los Angeles 1983)

Jack, Belinda, *Beatrice's Spell: The Enduring Legend of Beatrice Cenci* (London 2005)

Massinelli, Anna Maria, *Giacomo Raffaelli (1753-1836): Maestro di stile e di mosaico* (Florence 2018)

Mosaici minuti a Roma del 700 e 800, exh. cat. (Braccio di Carlo Magno, Vatican City 1986)

Schroder, Timothy (ed.), *The Gilbert Collection at the V&A* (London 2009)

Shelley, Percy Bysshe, *The Cenci: A Tragedy in Five Acts* (London 1819)

Sherman, Anthony C., *The Gilbert Mosaic Collection* (West Haven, CT 1971)

Truman, Charles, *The Gilbert Collection of Gold Boxes* (Los Angeles 1991)

Truman, Charles, *The Gilbert Collection of Gold Boxes*, vol. 2 (London 1999)

Voccoli, Ottobrina, and Michael Brunner, *Europäische Mosaikkunst vom Mittelalter bis 1900* (Petersberg 2013)

Voermann, Ilka, *Die Kopie als Element fürstlicher Gemäldesammlungen des 19. Jahrhunderts* (Berlin 2012)

Winckelmann, Johann Joachim, *Abhandlung von der Fähigkeit der Erfindung des Schönen in der Kunst* (Dresden 1763)

Yakovleva, Ekaterina, 'Collectors and Collections: Italian mosaics in the State Hermitage Museum', *Andamento* (2016), vol. 10, pp. 12–21

Zech, Heike, *Gold Boxes: Masterpieces from the Rosalinde and Arthur Gilbert Collection* (London 2015)

Zech, Heike, *Mosaics of St Paul's Cathedral* (London 2015)

Zech, Heike, with Ilona Jesnick, '"A Useful Occupation": The Opus Criminale Work of Women Prisoners in the Mid-nineteenth Century', *Andamento* (2015), vol. 9, pp. 34–42

All micromosaics from the Rosalinde and Arthur Gilbert Collection can be found in *Search the Collections* on the V&A website: www.vam.ac.uk

no. 30 (detail)

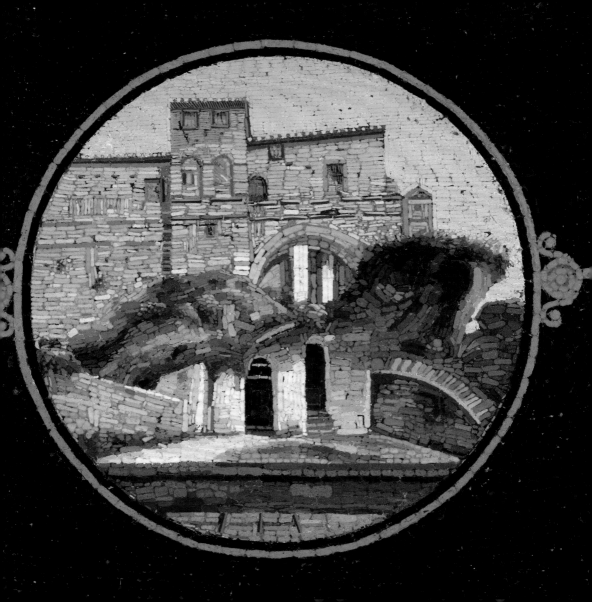

CONCORDANCE

The following list is an overview of V&A museum numbers. The numbers in brackets refer to the most recent Gilbert Collection micromosaics catalogue by Jeanette Hanisee Gabriel (JHG, 2000) as well as the MM (for micromosaic) and GB (for gold boxes) numbers assigned by the Gilberts themselves. No. 12 is owned by Los Angeles County Museum of Art (LACMA), a gift from Lady Marjorie W. Gilbert in honour of Sir Arthur Gilbert.

Fig. 1. Loan:Gilbert.203:1–2008 (JHG, 5; MM237)
Fig. 2. Loan:Gilbert.197–2008 (JHG, 147; MM108)
Fig. 3. Loan:Gilbert. 893–2008 (JHG, 29; MM46)
Fig. 4. Loan:Gilbert.924:1–2008 (ex. cat.)
Fig. 5. GAM 7423, Galleria d'Arte Moderna, Milan (photograph Umberto Armiraglio © Victoria and Albert Museum)
Fig. 6. Loan:Gilbert.4:1–4–2008 (JHG, p. 19; MM243)
Fig. 7. C.92&A–1922, Victoria and Albert Museum, London
Fig. 8. Loan:Gilbert.1056:1–2008 (JHG, 93; MM41)
Fig. 9. Private collection (photograph Jeremy Dillon)

1. Loan:Gilbert.171:1, 2–2008 (JHG, 7; MM33A)
2. Loan:Gilbert.155–2008 (JHG, 193, MM261)
3. Loan:Gilbert.164–2008 (JHG, 166; MM294)
4. Loan:Gilbert.159–2008 (JHG, 168; MM292)
5. Loan:Gilbert.937:1–2008 (JHG, 105; MM132)
6. Loan:Gilbert.483:1–2008 (JHG, 106; MM136)
7. Loan:Gilbert.110&111–2008 (JHG, 13; MM200)
8. Loan:Gilbert.176:1, 2–2008 (JHG, 10; MM281B)
9. Loan:Gilbert.884–2008 (JHG, 37; MM68)
10. Loan:Gilbert.144–2008 (JHG, 189; MM197)
11. Loan:Gilbert.474–2008 (JHG, 27; MM269)
12. LACMA: M.2010.55a–b. (JHG, 44; MM75); Los Angeles County Museum of Art; Gift from Lady Marjorie W. Gilbert in honor of Sir Arthur Gilbert. Photo © Museum Associates / LACMA
13. Loan:Gilbert.195–2008 (JHG, 158; MM97), comparison:Loan:Gilbert.194–2008 (JHG, 11; MM162)
14. Loan:Gilbert.349:1, 2–2008 (JHG, 6; GB 80)
15. Loan:Gilbert.433–2008 (JHG, 124; GB 163)
16. Loan:Gilbert.202–2008 (JHG, 24; MM222)
17. Loan:Gilbert.199–2008 (JHG, 45; MM204)
18. Loan:Gilbert.221–2008 (JHG, 40; MM260)
19. Loan:Gilbert.489:1, 2–2008 (JHG, 23; MM123A)
20. Loan:Gilbert.153–2008 (JHG, 54; MM78)
21. Loan:Gilbert.162–2008 (JHG, 167; MM216)
22. Loan:Gilbert.886–2008 (JHG, 53; MM109)
23. Loan:Gilbert.214–2008 (JHG, 35; MM277)
24. Loan:Gilbert.883–2008 (JHG, 65; MM70)
25. Loan:Gilbert.1057–2008 (JHG, 99; MM42B)
26. Loan:Gilbert.475–2008 (JHG, 137; MM238)
27. Loan:Gilbert.963:1 to 12–2008 (JHG, --; MMxx)
28. Loan:Gilbert.142–2008 (JHG, 188; MM246)
29. Loan:Gilbert.131:1&132:1, 2–2008 (JHG, 187; MM249)
30. Loan:Gilbert.119–2008 (JHG, 31; MM270)
31. Loan:Gilbert.226–2008 (JHG, 47; MM88)
32. Loan:Gilbert.892–2008 (JHG, 36; MM199)
33. Loan:Gilbert.894:1–2008 (JHG, 32; MM272)
34. Loan:Gilbert.430–2008 (JHG, 15; GB 199)
35. Loan:Gilbert.138–2008 (JHG, 175; MM107)
36. Loan:Gilbert.156–2008 (JHG, 21; MM142)
37. Loan:Gilbert.139 to 141–2008 (JHG, 186; MM248)
38. Loan:Gilbert.936:1–2008 (JHG, 63; MM128)
39. Loan:Gilbert.218–2008 (JHG, 42; MM115)
40. Loan:Gilbert.472:1–2008 (JHG, 41; MM316)
41. Loan:Gilbert.219–2008 (JHG, 90; MM301)
42. Loan:Gilbert.431–2008 (JHG, 11; GB 82)
43. Loan:Gilbert.207&208–2008 (JHG, 49; MM132CD)
44. Loan:Gilbert.124:1–2008 (JHG, 48; MM273)
45. Loan:Gilbert.177–2008 (JHG, 86; MM27)
46. Loan:Gilbert.170:1–2008 (JHG, 56; MM150)
47. Loan:Gilbert.126–2008 (JHG, 102; MM300)
48. Loan:Gilbert.122–2008 (JHG, 67; MM289)
49. Loan:Gilbert.1053:1–2008 (JHG, 100; MM17)
50. Loan:Gilbert.120:1–2008 (JHG, 77; MM283)

DEDICATION

This volume is dedicated to the pioneering micromosaic scholars who were entrusted by Rosalinde and Arthur Gilbert with the publication of their collection: Jeanette Hanisee Gabriel, Los Angeles, whose catalogue, published in 2000, is the collection's most recent scholarly assessment, Anna Maria Massinelli, Florence, and Alvar González-Palacios, Rome. Without their ongoing contributions to scholarship on micromosaics this guide would not have been possible.

ACKNOWLEDGEMENTS

My thanks are due to the Gilbert Trust for the Arts, London, and the Gilbert Public Arts Foundation, Los Angeles, for generously funding this publication. I would also like to acknowledge the many colleagues who supported this project from London and elsewhere. In particular, I would like to thank the V&A's Gilbert Collection team around Charlotte Johnson as Acting Curator of the Collection as well as Jasmine Clarke and Anna White; Tessa Murdoch and Mariam Sonntag; the colleagues at V&A Publishing, in particular Karen Fick and Coralie Hepburn; the V&A Photographic Studio, particularly Christine Smith and Richard Davis; Guglielmo Melodia, London, for confirming the source for no. 1; Rosie Mills, the Rosalinde and Arthur Gilbert Foundation Associate Curator of Decorative Arts, Los Angeles County Museum of Art; Kirsten Haydon, Melbourne; my colleagues at the Germanisches Nationalmuseum, Nuremberg; and Ekaterina Yakovleva, Keeper of Mosaics at the State Hermitage, St Petersburg.

INDEX

Page numbers in *italic* refer to the illustrations

First published by V&A Publishing, 2018
Victoria and Albert Museum
South Kensington
London SW7 2RL
www.vandapublishing.com

Distributed in North America by Abrams,
an imprint of ABRAMS

The moral right of the author has been
asserted.

ISBN 978 1 85177 970 3

10 9 8 7 6 5 4 3 2 1
2022 2021 2020 2019 2018

A catalogue record for this book is
available from the British Library.

Unless otherwise stated, images are
courtesy of the Rosalinde and Arthur
Gilbert Collection, on loan to the Victoria
and Albert Museum, London.

Every effort has been made to seek
permission to reproduce those images
whose copyright does not reside with the
V&A, and we are grateful to the individuals
and institutions who have assisted in
this task. Any omissions are entirely
unintentional, and the details should be
addressed to V&A Publishing.

Design: Joe Ewart, Society
Copy-editor: Charlotte Chapman
Proofreader: Linda Schofield
Origination: DL Imaging
Index: Hilary Bird
New V&A photography by Christine Smith,
V&A Photographic Studio
Printed in China

Where objects are reproduced at actual
size this is indicated in the text. Unless
otherwise stated, measurements given
are for the micromosaic.

Front cover: no. 13
Back cover: no. 8

V&A Publishing

Supporting the world's leading
museum of art and design,
the Victoria and Albert
Museum, London